THE ART OF FAITH

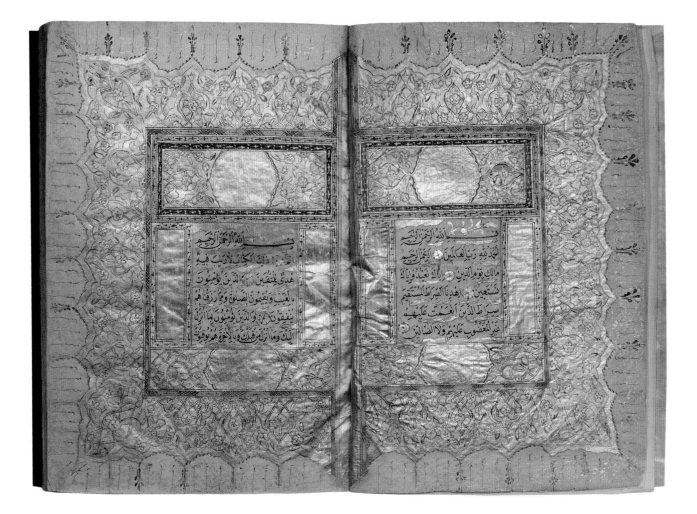

بسم الله الرحمن الرحيم
الم ذلك الكتاب لا ريب فيه
هدى للمتقين ° الذين يؤمنون
بالغيب ويقيمون الصلوة ومما رزقناهم
ينفقون ° والذين يؤمنون بما أنزل
إليك وما أنزل من قبلك وبالآخرة هم يوقنون °

بسم الله الرحمن الرحيم
الحمد لله رب العالمين ° الرحمن الرحيم °
مالك يوم الدين ° إياك نعبد وإياك
نستعين ° اهدنا الصراط المستقيم °
صراط الذين أنعمت عليهم °
غير المغضوب عليهم ولا الضالين °

THE ART OF FAITH

3,500 YEARS OF ART AND BELIEF IN NORFOLK

Edited by Andrew Moore and Margit Thøfner

With contributions by
John Davies
Sandy Heslop
Elizabeth Mellings
Timothy Pestell
Francesca Vanke

and a foreword by Stephen Fry

NORFOLK Museums
& Archaeology Service

Philip Wilson Publishers

University of East Anglia

First published in 2010
by Norfolk Museums & Archaeology Service
in association with Philip Wilson Publishers

Philip Wilson Publishers
109 Drysdale Street
The Timber Yard
London N1 6ND
www.philip-wilson.co.uk

Distributed throughout the world
(excluding North America) by:
I.B. Tauris & Co. Ltd
6 Salem Road, London W2 4BU

ISBN 978-0-85667-693-2

Edited by Andrew Moore and Margit Thøfner

Editor for Philip Wilson Publishers: David Hawkins

Designed by Caroline and Roger Hillier
The Old Chapel Graphic Design
www.theoldchapelivinghoe.com

Printed and bound in China by Everbest

The Art of Faith is supported by the
Arts and Humanities Research Council

Arts & Humanities
Research Council

Half-title page:
Angel sounding the trumpet, c. 1100, detail from the earliest known
surviving series of large-scale wall paintings in England
The Church of St Mary the Virgin, Houghton-on-the-Hill, Norfolk

Frontispiece:
Qur'an, 1799–1800 (1214 AH)
Ibrahim Hajiz al-Qur'an
Ottoman Empire
Ink on paper, gilt leather binding
13.5 x 9.5 x 2 cm
The Denys Spittle Collection
Religion has inspired artists across culture and time. This beautifully
penned and gilded Qur'an exemplifies the supreme importance
of calligraphic art to Islam, which stems from the centrality of the
written word to this faith.

These folios are the most highly decorated of the volume,
emphasising the importance of the text of the first two *surahs* or
chapters, of the Qur'an. However elaborate, decoration used
in a sacred context is always non-figurative. It is considered
blasphemous to depict living things, as if imitating the creative
power of God.

This Qur'an was first acquired by a British collector sometime
in the nineteenth century, and was bequeathed to a noted East
Anglian antiquarian. Although not used for devotional purposes
for at least 100 years, the beauty of this book shows clearly the
timeless nature of a sacred work of art. FV

Contents

LENDERS

Her Majesty The Queen: 5.7

Norfolk, Church of St Michael the Archangel, Booton, The Churches Conservation Trust: 5.28
Norfolk, Church of St Mary and the Holy Cross, Binham: 3.8
Norfolk, Church of St James the Great, Castle Acre: 2.17
Norfolk, Church of St Agnes, Cawston: 3.11
Norfolk, Church of St Nicholas, North Walsham: 4.6
Norfolk, Church of St Helen, Ranworth: 2.19
Norfolk, Church of St Mary, Sparham: 2.26
Norfolk, Church of St Clement, Terrington St Clement: 2.25
The Thetford Quilters, The Church of Jesus Christ of Latter-day Saints (Mormon): 6.14
A Norfolk church: 4.7
A Norfolk Pagan Coven: 4.10
Norwich, Church of St Andrew: 3.1
Norwich Cathedral: 1.22, 2.20, 2.21
Norwich, Roman Catholic Diocese of East Anglia: 5.16 – 5.18
Norwich Orthodox Synagogue: 5.2, 5.14
Norwich, The Octagon Chapel: 6.1
Norwich, Church of St Peter Mancroft: 2.22, 2.23
Norwich Quaker Patchwork & Quilters: 6.2
Norwich, Church of St Stephen: 2.24
Norwich, United Reformed Church: 5.11
Norwich and Norfolk Indian Society: 6.13
Suffolk, Church of the Holy Trinity, Long Melford: 4.12
Suffolk, Church of St Mary, Preston St Mary: 3.18

Imogen Ashwin: 6.11
Gary Breeze: 6.10
Margie Britz: 2.11
The Duke of Buccleuch & Queensberry KBE: 3.6
Judith Campbell: 6.4
Viscount Coke and Holkham Hall: 5.2
John Goto: 3.10
Nawala Hoggett: 6.7
Susan Laughlin: 1.11
Chris Loukes: 6.3

Nicky Loutit: 6.8
Liz McGowan: 2.12
The Duke of Norfolk: 2.5
Henry Paston-Bedingfeld of Oxburgh Hall, Norfolk: 3.13
Private collections: 1.4, 2.16, 2.28, 5.12, 5.13, 5.30, 6.6, 6.12
The Denys Spittle Collection: frontispiece
Andrew Wilkinson: 6.5

Cambridge, Corpus Christi College: 2.6
Cambridge, Pembroke College: 4.2, 4.11
Cambridge University Library: 3.15, 4.4
Ely, The Stained Glass Museum, on loan from the Diocese of Norwich: 5.26
Glasgow Museums, The Burrell Collection: 2.7
London, British Library: 2.2, 4.5
London, British Museum: 1.1, 1.2, 1.5, 1.7, 1.9, 1.15 – 1.18
London, Lambeth Palace Library: 2.27
London, Museum of London: 2.3
London, The National Archives: 2.1
London, National Portrait Gallery: 5.4, 5.9
London, Senate House Library, University of London: 3.9
London, Victoria & Albert Museum: 2.8, 4.1, 3.12
Norfolk, Gressenhall Rural Life Museum: 4.14, 5.25
Norwich, Carrow House Costume & Textile Study Centre: 2.18
Norwich Castle Museum & Art Gallery: 1.3, 1.6, 1.8, 1.10, 1.12 – 1.14, 1.19 – 1.21, 1.23, 1.24, 2.9, 2.10, 2.13, 2.15, 2.29, 2.30, 3.2, 3.5, 3.16, 3.19, 4.3, 4.8, 4.9, 5.3, 5.5, 5.6, 5.8, 5.19, 5.20, 5.22 – 5.24, 5.27, 5.31, 6.9
Norwich Castle Museum & Art Gallery, on loan from Norwich Historic Churches Trust: 2.4
Norwich City Council Civic Regalia Collection: 3.4
Norwich Civic Portrait Collection: 3.3, 3.17
Norwich, Norfolk Record Office: 4.13
Norwich, Norfolk Record Office (Archives of the Roman Catholic Diocese of East Anglia): 5.10
Norwich, Strangers Hall: 4.15, 5.21, 5.29
Oxford, Ashmolean Museum: 2.14
Thetford, Ancient House Museum: 3.14, 5.15
West Sussex, Arundel Castle: 3.7

Foreword

Many of us, when thinking of East Anglia, and of Norfolk in particular, conjure up in our mind's eye the low-lying landscapes with their medieval churches beneath wide-ranging skies that are such a feature of this fertile land. Over the centuries the spiritually evocative landscape of Norfolk and Suffolk has attracted many artists and craftsmen, who through time have tried to capture its magic with their skills.

This book represents a unique endeavour to chart the impact of this wonderful region of Great Britain on those artists and makers who have attempted to express something of its spiritual nature across more than three thousand years. The history of Christianity within this time is, in fact, part of a larger continuum which began with Pagan beliefs and continues today with an increasingly rich diversity of faiths. The power of artefacts to express our relationship with both a place and our devotional practices is surely nowhere clearer than here, an area bounded to the north by the Wash, to the west by the Fens, to the south by the river Stour and to the east by the North Sea, a conduit to mainland Europe and Scandinavia. In the Middle Ages this was the Diocese of Norwich but what is contained in these pages is by no means an exclusively Christian narrative, nor always a happy one. The artefacts shown here tell many stories – and in so doing speak for all of us across time and for the very idea of faith as a rich and diverse phenomenon.

Stephen Fry.

Introduction & Acknowledgements

This book celebrates the impact of faith on the art of a region with a long history of migration and diverse belief patterns. The universality of the theme and its clear relevance to the region's history and cultural identity makes this a celebration of more than local importance, with a reach well beyond that of the traditional survey. This publication is just one outcome of a partnership between Norfolk Museums & Archaeology Service and the School of World Art Studies & Museology at the University of East Anglia, for which we were awarded a full research grant by the Arts and Humanities Research Council.

Across the centuries, Norfolk has been the home to many and varied faiths. Vikings, Anglo-Saxons and Romans all came with their own belief systems. During the Roman period, Christians also settled in this area and eventually – after a period of conflict – Christianity became the official religion. This, however, did not prevent other faiths from flourishing. For example, in the middle ages there were thriving Jewish communities in Thetford, Bishops (now Kings) Lynn and Norwich even if these often suffered under severe persecution from their Christian fellow citizens. Later, from the fifteenth century onwards, religious diversity took the form of a bewildering number of different branches of Christianity.

In Norfolk, amongst others, there were Lollards, Catholics, Calvinists, Laudians, Puritans, Huguenots, Presbyterians and Quakers. In this region, the official and uniform religion of Christianity can be seen as only ever a general truth. Over the past two centuries a new pattern of diversity has emerged. To mention but a few of the faiths now practised by the citizens of Norfolk: there are Sikhs, Muslims, Pagans, Buddhists and Hindus as well as older and more recently formed communities of Jews and Christians.

Forming part of our celebration of this diversity, the present

publication is a record of the exhibition *The Art of Faith*, held at Norwich Castle Museum & Art Gallery (2 October 2010 – 23 January 2011). It is a celebration especially of works of art and other artefacts made to serve or to give material form to the different faiths of Norfolk. Each chapter charts the chronology of the effect of faith on the region's cultural development and also incorporates a contemporary work of art to show the continuing impact of belief on artists working to make sense of our place in the world today. The final section brings the story up to date, and ends with a contemporary video film commissioned from Chris Newby, whose *Something understood* (2010) focuses on the devotional practice of prayer. This is the one aspect of belief that is perhaps missing from a gathering of material culture, albeit evinced by the artefacts themselves.

We have been delighted to be in a position to work with a team of colleagues at both Norwich Castle and the University of East Anglia from whom we have received considerable support as the project has developed. Francesca Vanke has headed the Norwich Castle team and we particularly thank Francesca for her help over both this publication and the curation of the exhibition. The Castle team has been ably supported by Fi Hitchcock, who has dealt with all aspects of the administration of loans for the project. We have also enjoyed the support of members of the Interfaith Advisory Group in selecting the exhibition and negotiating any issues of faith raised by this subject, notably Shan Barclay, Miriam Barnett, John Cary, Dora Cowton, Helen Jenkins, Ujjal Singh Kular, Norman Manners, Padmadaka, Betty Rathbone, David Roberts, Anne and Michael Sanderson, Peter Varney, Gayatri Verma, Frances Warns, Natasha Wilkinson, and George Willson. This group provided essential help to Chris Newby in the preparation of his film commission, as did Harriet Godwin who acted as principal support for Chris on behalf of the project. We also wish to thank the Right Rev. Bishop of Norwich, Graham James for his early support and fellow members of the project board, John Davies, Simon Dell and Howard Green for their continuing guidance. Above all we thank the lenders to the exhibition, who are listed separately on page 6, without whose support this project would not have been possible. In addition to the parish councils who are supporting the exhibition, we would also like to acknowledge the help provided by the Diocesan Advisory Committees of Norwich, Ely and St Edmundsbury & Ipswich.

We are indebted to our contributing authors John Davies, Sandy Heslop, Elizabeth Mellings, Tim Pestell and Francesca Vanke, all of whom have championed individual works of art for the sections they have authored. The authors of each chapter have written the entries for those sections, unless otherwise indicated by initials of contributing colleagues. We would also like to thank Stephen Fry for contributing the foreword. The project has benefited greatly from the support of Kate Hesketh-Harvey, who has undertaken much research into works of art under consideration. The project – and indeed artists living in the locality – have also greatly benefited from the appointment of Elizabeth Mellings as Post Doctoral Fellow, with the specific remit of researching the impact of faith on contemporary artists at work in the region. In addition, during all phases of the project, we have drawn on the work, help and support of several groups of undergraduate students in the School of World Art & Museology. Simon Dell kindly managed the project during a critical period. We are deeply indebted to all of these individuals, without whom our project would not have come to fruition. Finally, we would like to express our appreciation of Anne Jackson, David Hawkins, designers Roger and Caroline Hillier, and the team at Philip Wilson for their attention through every stage of this publication.

Andrew Moore and Margit Thøfner

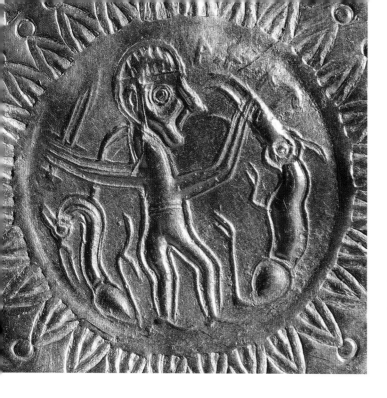

1

CONQUEST TO CONQUEST: LOCALS, ROMANS, ANGLO-SAXONS AND VIKINGS

Tim Pestell

Understanding how past societies expressed their beliefs has long proven a thorny issue for archaeologists. There can be enormous difficulties in comprehending the use of objects as part of belief systems, or the manner of their preservation in the archaeological record. Equally, we see recurring aspects, such as tensions between sacred and profane worlds, changes or continuity in faith, and the relationship between elites and their subjects. A characteristic of many early societies is the presence of material that has been deliberately deposited in the ground and which has therefore been interpreted as offerings to supernatural forces. Given that we have no evidence from these early peoples to say why they acted in certain ways, it can be difficult to interpret objects in deposits as 'ritual' or relating to beliefs, as they may have been buried for safekeeping.

A potent example is the Oxborough dirk, an early Middle Bronze Age weapon of c. 1500–1350 BC (1.1). Its design is similar to numerous other dirks of this date. Yet it was clearly not made to be used, lacking both sharpened edges and attachment points for a handle. Most remarkable is its massive size; it is at least twice as long as most normal dirks from this period. Found set vertically in peat, blade down, the dirk had originally been placed in a boggy location. This deposition must have represented a considerable investment of resources by its owner, so it is surely no coincidence that it was shaped as a weapon. In this period, wealth was based on the ability to produce a surplus of foodstuffs, lifting persons or societies above subsistence. The use of weapons to protect resources, or forcibly relieve other people of theirs, illustrates the link between warfare and offerings for success in battle. And what could be more potent than offering up a giant weapon?

By the Iron Age, some were apparently prepared to invest still more tangible riches to secure favour. Of all the archaeological finds from Norfolk, the gold and silver torcs of Ken Hill, Snettisham are perhaps the most famous. They represent a phenomenal store of wealth, the burial of which was, significantly, deliberately structured in form (1.2). Equally significant was the emphasis that early societies placed on the landscape surrounding such deposits: while the Oxborough dirk was deposited in a watery site, like many other Bronze Age

weapons, so Ken Hill's prominent views over the surrounding landscape chimes with other elevated Iron Age ritual sites.

By contrast, the Roman period came with a more direct personification of the gods, seen archaeologically in the representation of many as small figurines and statues. A new pantheon was brought to the fore, as was state-sponsored worship of the Imperial family. The long Roman military presence also led to the import of more exotic cults, notably of African and oriental deities. However, less militarised areas like Norfolk saw a more syncretic approach to religion, combining Roman and Celtic deities, such as Mars Corotiacus at Martlesham in Suffolk, while inscribed on spoons in the Late Roman Thetford hoard of silverware are six names in addition to that of the Roman god Faunus: Andicrose, Ausecus, Blotugus, Cranus, Medigenus and Narius. All were presumably local deities and demonstrate how the existing population adapted to new political realities while maintaining or revising old traditions.

However, one imported cult was to prove of particular significance and in time came to displace all other faith systems: Christianity. Evidence of its development in Roman Britain is largely limited to a few important finds and hoards, most commonly identified by their use of the *chi-rho* monogram. Finds from eastern England attest to the spread of this new cult among the aristocracy, such as the silver vessels in the Water Newton hoard from Huntingdonshire or the three lead tanks, sometimes called baptismal fonts, from Icklingham in Suffolk. The latter site also revealed a possible late Roman church and cemetery in excavations.

The fall of Roman Britain following 410 AD was also the beginning of a new, more Germanic culture and with it came new forms of belief and practice. Understanding these beliefs is difficult because the early Anglo-Saxons left no explicit records of their thoughts and convictions. Instead, we have to rely on later, Christian writers to inform us about a world which they and their agents were bent on destroying.

Bede, a Benedictine monk, wrote his *Ecclesiastical History of the English Church and People* not as a modern historical record but as a celebration of the march of Christianity and the spiritual benefits accruing to converted rulers. Once again, we see the hand of social elites in maintaining their own power whilst structuring religious practice and shifting the perception of what 'proper' faith constituted. Aristocratic influences are exceptionally clear in the wealth of patronage given to the early Church. Extensive grants of land, by now recorded on parchment charters, intricately-decorated manuscripts and magnificent liturgical items made of precious metals – like the gold cross recently found within the seventh-century Staffordshire Hoard – must have all created a literally dazzling spectacle. Nevertheless, it was the ordinary peons who actually paid for these items through taxation and the creation of agricultural surpluses.

A potent expression of royalty's central role in the promotion of Christianity was the martyrdom of King Edmund of East Anglia by the Vikings in 869 AD (2.5). As was often the case, this death was used as a rallying point for the subjugated local population. Veneration of the dead king quickly led to a memorial issue of coinage, by which the new Danish rulers of East Anglia were obliged to acknowledge their victim's sanctity. In turn, this was a move meant to help stifle a focus for resistance.

The apparently speedy conversion of the immigrant Danes – quite possibly a small ruling aristocracy and their retainers – now led East Anglia to a period of religious stability. The unusually large 'free peasantry' of East Anglia appears to have led to a surge in parochial provision by the eleventh century, with many thegns, the local landowners, choosing to demonstrate their faith, status and wealth through the construction of small estate churches. By the Norman Conquest Norfolk was awash with churches, in one of the densest concentrations in northwestern Europe. The canvas for the extensive medieval patronage of the Christian Church had been painted.

1.1 BRONZE AGE CEREMONIAL DIRK

c. 1500–1350 BC
Oxborough, Norfolk
Copper alloy
71 × 18.1 cm
Trustees of the British Museum

Norfolk is rich in Bronze Age metalwork.
New forms appeared in the Middle
Bronze Age, including dirks, which were
stabbing weapons, fitted with handles which
were secured in place by metal rivets. The
Oxborough dirk was discovered in peat, at
an originally watery location in west Norfolk.
Its massive size makes it unique.[i]

This is one of the most spectacular
prehistoric objects ever discovered in Britain.
In its form, it resembles the much smaller
early-Middle Bronze Age dirks. However, it
is much too large and unwieldy to have ever
been used as a weapon. In addition to its
unusual size, the edges of the blade, although
neatly fashioned, are deliberately blunt. At the
butt end, no rivet holes were ever provided to
enable it to be attached to a handle.

Ritual deposition accounts for many
individual bronze items recovered from
Britain. The vast majority of Bronze Age
artefacts from Norfolk are certainly the result
of deliberate deposition, where there was no
intention of recovery. This massive dirk was
clearly never intended to be functional in any
practical way. It was probably designed for
ceremonial use and was eventually the subject
of ritual deposition. It matches, in terms of scale,
form and style, a small number of examples from
Holland and France, similarly thought to have
been ceremonial weapons, and known as the
Plougrescant-Ommerschans type. *JD*

1.2 IRON AGE TORCS

c. 75 BC
Snettisham, Norfolk
Silver and electrum
Diameters 22.5 & 17.7 cm
Trustees of the British Museum

Torcs are a form of metalwork
which characterise the Iron Age
period right across Europe. They
were essentially an elaborate form
of jewellery, worn as neck rings
by people of high status. More
torcs have been found in East
Anglia than in the rest of Britain.
In particular, the west of Norfolk
has yielded numerous examples,
from sites including North Creake,
Marham, Bawsey and Sedgeford,
although most examples come
from a single location, at Ken
Hill, Snettisham.

The first recorded discovery at
Snettisham was in 1948, during
ploughing. Subsequent finds
were made on a sporadic basis
until 1990, when excavations at
the site were undertaken by the
British Museum and those latest
discoveries have made this the
biggest collection of Iron Age
Celtic metalwork ever discovered
in the British Isles.

From the many fine and
striking examples within the
illustrated group it is interesting
to consider two contrasting torcs,
both complete and in excellent
condition. The first (far right) is

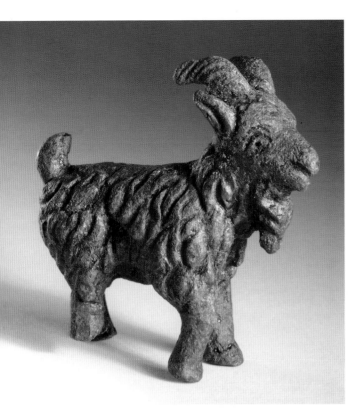

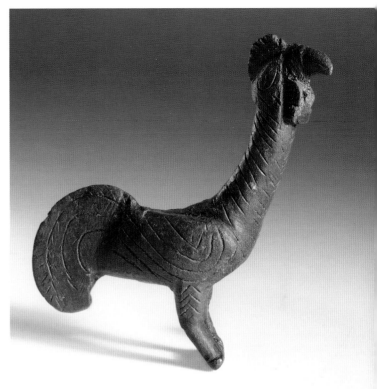

1.4 VOTIVE OFFERINGS, A GOAT AND COCKEREL
Romano-British
Great Walsingham, Norfolk
Copper alloy
Height 5.1 x length 5.5 cm; height 5.9 cm
Private collection

Scrutiny of the known Romano-British settlement at Great Walsingham in recent years has revealed evidence for a substantial small town of that period. Among the many finds from the site are objects which confirm the presence of a temple. These include three Mercury figurines, two goats, three cockerels, together with anthropomorphic busts and masks, inscribed finger rings, votive letters and other model objects, such as miniature axes.[v] Together, they form one of the finest collections of religious items from Roman Britain. Two of the zoomorphic figurines are particularly striking.

The goat figurine is solid cast and heavy. It is very fine and naturalistically modelled, with clearly defined details for the horns, beard and curly fleece. The tail is curled upwards, while the head slightly inclines to the right. The eyes are defined by punched holes, which are not level; neither are the ears. Goats are animals that were often associated with the god Mercury and were sometimes depicted with him.

The cockerel is another figurine of great character. The head is turned half right and sits on an elongated neck. Details of the plumage are shown by incisions in the curves and the tail feathers by semicircles and hatching. The wings are defined by rounded chevrons. There are hatched lines on the neck and comb. The figurine exhibits a lack of symmetry in key features; the left eye is round and the right is oval. At the same time, there are no feet and the lower legs are joined by a short crossbar, presumably for attachment. The cock is also recognised as an attribute to the god Mercury. *JD*

1.5 TWO DRINKING CUPS WITH BACCHIC MOTIFS

Late first century AD
Hockwold-cum-Wilton, Norfolk
Silver; height 9.5 cm, diameter 9.3 cm
Trustees of the British Museum

A group of fragmentary silver drinking cups was found on the south-eastern fen-edge in 1962. They may have been buried as a votive deposit at an early Romano-British shrine. They had certainly been deliberately dismantled and crushed before burial. A total of twenty-four fragments were discovered, which represent at least seven original vessels.[vi] They had formerly been a collection, or set, of high quality tableware.

Roman wine cups were normally made in matching pairs. The Hockwold examples have now been restored to their original form and they comprise two matching *kantharoi*, one cup without handles and one undecorated handled cup. The group also contains two pairs of handles and a pedestal base.

The illustrated examples (*kantharoi*) form one of these matching pairs, each with a waisted form and a small pedestal base and handles. The exteriors are richly decorated; below each rim is a panel of circular punch marks, crossed at intervals by oblique lines, with a hanging vine leaf below and a further frieze of pairs of ivy leaves rising from vertical stems. The lower zone of each has four acanthus leaves rising from the base. Bacchic motifs hang from the central moulding, which are of flutes, pan-pipes, cymbals and tambourines. There are attachments to the upper handles in the form of branches with ivy leaves.

The nature of the damage to these cups indicates that they were not buried for safety. It is possible that they represent loot, possibly associated with the Boudican rebellion.[vii] However, the favoured interpretation is that they were a votive deposit, buried for religious reasons. Two Romano-British temples are known to have existed in the near vicinity at Hockwold-cum-Wilton. *JD*

1.6 ROMANO-BRITISH CREMATION URN WITH LID

69–96 AD
Hockwold-cum-Wilton, Norfolk
Glass; height 22.5 cm, rim diameter 12.2 cm
Norwich Castle Museum & Art Gallery

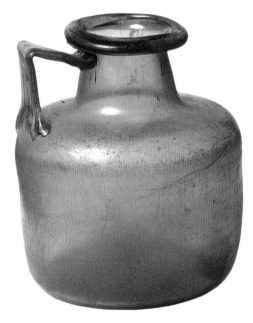

Roman burials are not commonly encountered in Norfolk. Just 245 examples are known, which represent a tiny proportion of the population of Roman Norfolk, over a period of 360 years.[viii] Of these, 168 were inhumations, while just seventy-seven were cremations. The beautiful glass cremation urn from Hockwold-cum-Wilton was discovered during the mid-nineteenth century and was found inside a hillock, possibly a burial mound, standing on a floor of decayed oak planks. It originally contained cremated human bone and was positioned below a skeleton.

The straight-sided vessel is made of translucent green glass, with a flat bottom. It has a rounded shoulder, funnel neck and broad rim to the opening. There is an applied strap handle and a separate circular domed lid, which has a shallow knob.

It was following the Roman invasion of Britain, and as a result of the spread of Roman customs, that cremation became the main burial rite across lowland Britain. The small number of cremations found may indicate that the practice was restricted to upper classes and Romanised Britons.[ix] From the mid-second century there was a steady trend away from cremation towards inhumation. *JD*

1.7 SIX ANGLO-SAXON DISC BROOCHES

First third of the ninth century AD
Pentney, Norfolk
Silver, niello; diameters 7–8 cm
Trustees of the British Museum

This remarkable hoard of Late Anglo-Saxon disc brooches, discovered in Pentney churchyard in 1977, amply illustrates the wealth of Late Anglo-Saxon England as well as the intimate relationship between patronage of the arts, the aristocracy and the Church. An obvious manifestation of this is the prominent cross design on all the brooches, a recurrent motif in most such objects of this date. Moreover, the animal ornament in two of the pairs of brooches shows close stylistic links with the ninth century Book of Cerne, a private prayerbook, and the Cotton Tiberius manuscript of Bede's *Ecclesiastical History*. These similarities show how this form of decoration was used in both secular and ecclesiastical contexts.

The find-spot may be an important early church site, not least because a decorated stylus of a similar date was found in an adjacent field. The workshop producing the Pentney brooches may well have been local. This is suggested by the 'bag-bellied' Trewhiddle-style beast on the largest brooch which is similar to one found on a copper-alloy trial piece from a nearby high-status site at Bawsey, also perhaps an early minster.[x]

1.8 BRACTEATE WITH THE ANGLO-SAXON GOD TÎW

Early sixth century; Binham, Norfolk
Gold (6.93 g, 83% pure); diameter 4.4 cm
Norwich Castle Museum
& Art Gallery

Bracteates are pendant ornaments of Scandinavian origin that were used in
the late fifth and sixth centuries AD. They are extremely rare. In Scandinavia
they are frequently found buried in hoards, often with ritual associations.

This example was found by metal-detection at Binham in 2003. It
shows a sword-wielding male figure engaged in combat with a beak-
headed quadruped. A second such beast is behind the man's right leg.
This imagery may represent a god performing a magical deed, forcing
demons into subservience, or more specifically, it may depict the Germanic
god Tîw fighting the mythical wolf Fenrir. A short, characteristically cryptic,
runic inscription above reads 'knows' or 'knowing'. This suggests that the
bracteate was possibly an amulet worn for protection.

The Binham bracteate was probably imported, having close parallels
with seven others from the Hamburg area and one from a Migration-period
grave in Derenburg, eastern Germany. This shows the strong cultural and
religious links between Norfolk and northern Continental Europe in the sixth
century. Moreover, the bracteate is one of only four such gold objects found
in Norfolk, all within a six-mile radius, which suggests direct foreign contacts
and the control of resources by a leading local family.

1.9 ANGLO-SAXON PLAQUE OF ST JOHN

Early ninth century
Brandon, Suffolk
Gold and niello; 3.4 x 3.4 cm
Trustees of the British Museum

One of the most striking pieces of Anglo-
Saxon ecclesiastical metalwork surviving,
this gold plaque from Brandon is engraved
and nielloed with a zoo-anthropomorphic
half-figure of St John the Evangelist. It
was clearly one of a set of four fittings
probably attached to a book cover or the
terminals of a processional cross.

Although diminutive, the piece
shows the wealth of the patron who
commissioned it and the sophistication of
the craftsman who made it. The plaque
is distinguished by strikingly powerful
imagery designed and executed with
elegant simplicity. The use of an animal
head on a human body is a rare feature
of Insular art, which chimes well with the
angular square capitals of the inscription,
which read SCS/EVA/N/GE/LI/ST/A
IO/HA/NNIS ('St John the Evangelist').
Together, image and inscription show the
quality of East Anglian design, evident
also in the Book of Cerne, produced in
neighbouring Mercia c. 818–30.

The plaque also highlights the
difficulties of interpreting the site at which
it was found. A high-status Middle Anglo-
Saxon settlement with an exceptionally
rich material culture, Brandon was
certainly an important place, either a
secular complex or a monastery, or
very likely both.

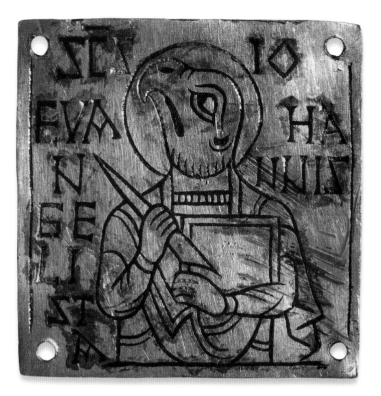

this god and the invoking of his protection. They also provide unequivocal evidence for non-Christian religious devotions and practices brought by the Scandinavian invaders to the British Isles.[xi]

In practice, the rapid Christianisation of the Danelaw under the influence of successive West Saxon kings meant that polytheistic Viking practices died out quite quickly, and with them use of amulets like Thor's hammers. The Witchingham hammer is therefore a rare archaeological find. It recalls a pivotal moment in English history when predominantly Danish immigrants first brought their own practices and beliefs before settling to help create a new, Christian, Anglo-Scandinavian population.

The Witchingham Thor's hammer is one of nine now known from Norfolk, the largest density of such amulets anywhere in the British Isles. Together, they underline Norfolk's important Viking heritage, as influential here as in other more widely-celebrated places like York and Dublin.

1.10 VIKING THOR'S HAMMER AMULET
Late ninth century
Great Witchingham, Norfolk
Silver and gold; 3.7 x 2.4 cm
Norwich Castle Museum & Art Gallery

Few objects capture Viking religious belief as succinctly as the Thor's hammer amulets worn as neck pendants. These miniatures represent *Mjöllnir*, the hammer used by the Norse god Thor to smite his enemies and therefore imply a particular devotion to

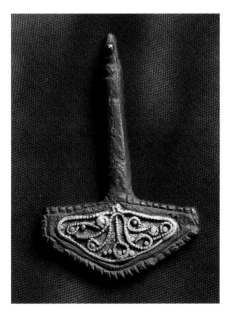

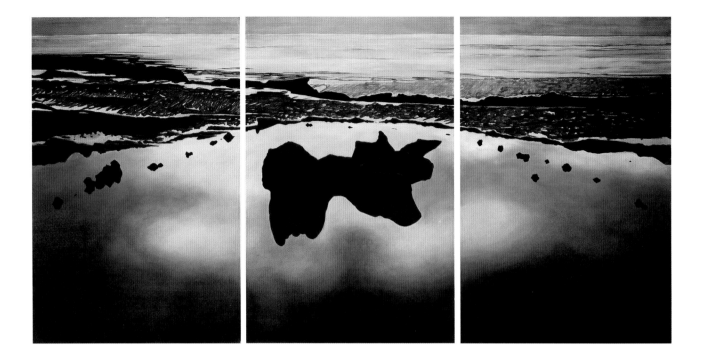

1.11 GLOWING EMBERS (SEAHENGE)

2000

Susan Laughlin (b. 1962, Ipswich)

Oil on canvas

Triptych panels, each 91.5 x 61 cm

Lent by the artist

Glowing Embers combines environmental imagery and triptych format so as powerfully to unite landscape and belief. The ancient henge represented here may have been a manifestation of the early belief that the meeting of land and sea formed the gateway between earthly and spiritual realms.[xii] As a practising Pagan, Laughlin's picture articulates the continued significance and potency of Seahenge for Pagans in Norfolk, a belief that generated strong objections to the removal of the henge to King's Lynn Museum. The matt-finished centre presents an unquantifiable depth at once suggestive of a mystic space and of the spiritual void left by the extraction of the henge. The triptych format, Laughlin explains, symbolises the Pagan maid-mother-crone moon phases and the fundamental cycle of life-death-rebirth. Laughlin aims to awaken viewers' post-industrial sense of responsibility for, and 'connectedness' with our 'precious and beautiful' landscape as a container of human history.[xiii] To her, the landscape reveals layers of memories, through which we might access our ancestral heritage and so come better to understand ourselves. *EAM*

1.12 ROMAN LAMELLA (AMULET)
60-150 AD
Billingford, Norfolk
Gold; 4.2 x 3 cm
Norwich Castle Museum & Art Gallery

1.13 ROMAN DEFIXIO (CURSE TABLET)
First–Fourth century AD
Caistor St Edmund, Norfolk
Lead; 10.5 x 6.5 cm
Norwich Castle Museum & Art Gallery

1.14 TWO ROMAN MERCURY FIGURINES
First–Fourth century AD
Great Walsingham, Norfolk
Copper alloy; 15.7 x 5.6 cm; 9.6 x 4.3 cm
Norwich Castle Museum & Art Gallery

1.15 ROMAN BUCKLE WITH SATYR
Fourth century AD
Thetford, Norfolk
Gold; height 5.2 cm
Trustees of the British Museum

1.16 ROMAN SPOON WITH PANTHER
DECORATION AND 'FAUNUS'
INSCRIPTION, Fourth century AD
Thetford, Norfolk
Silver, niello; 9.4 x 4.6 cm
Trustees of the British Museum

1.17 ROMAN DUCK-HANDLED SPOON
WITH 'FAUNUS' INSCRIPTION
Fourth century AD
Thetford, Norfolk
Silver, niello; 17.7 x 3.3 cm
Trustees of the British Museum

1.18 ROMAN RITUAL STRAINER
Fourth century AD
Thetford, Norfolk
Silver; 14.3 x 2.7cm
Trustees of the British Museum

1.19 ANGLO-SAXON CREMATION URN
WITH TÎW POT STAMPS, Fifth–sixth century AD
Spong Hill, North Elmham, Norfolk
Ceramic; 22 x 24 cm
Norwich Castle Museum & Art Gallery

1.20 FRAGMENT OF ANGLO-SAXON URN
SHOULDER WITH WOLF AND SHIP
Sixth century AD
Caistor St Edmund, Norfolk
Ceramic; 22 x 36 cm
Norwich Castle Museum & Art Gallery

1.21 ANGLO-SAXON CREMATION URN
Fifth–sixth century AD
Caistor St Edmund, Norfolk
Ceramic; 22 x 24 cm
Norwich Castle Museum & Art Gallery

1.22 HYDRIOTAPHIA, URNE BURIAL
1658 edition
Thomas Browne (1605-1682)
Printed book, modern binding; 22.3 x 18 cm
The Dean & Chapter of Norwich Cathedral

1.23 WODEN PENDANT, Seventh century AD
Attleborough, Norfolk
Copper alloy; 4.1 x 2.5 cm
Norwich Castle Museum & Art Gallery

1.24 THREE VIKING THOR'S HAMMERS
Late ninth–early tenth century
South Lopham, Surlingham and Thetford,
Norfolk
Gold, silver, lead
2.8–3.7 cm (max. dimensions)
Norwich Castle Museum & Art Gallery

Notes
i S. Needham, 'Middle Bronze Age ceremonial weapons: New finds from Oxborough, Norfolk and Essex/Kent', *Antiquaries Journal 70*, 1990, pp. 239-52.
ii I.M. Stead, 'The Snettisham Treasure: excavations in 1990', *Antiquity 65*, 1991, pp. 447-65.
iii J. Davies, 'Romano-British cult objects from Norfolk – some recent finds', *Norfolk Archaeology 42*, 3, 1996, p. 382.
iv C. Johns and T. Potter, *The Thetford Treasure*, London, 1983.
v J. Bagnall Smith, 'Votive objects and objects of votive significance from Great Walsingham', *Britannia 30*, 1999, pp. 21-56.
vi C. Johns, 'The Roman silver cups from Hockwold, Norfolk', *Archaeologia 108*, 1986, pp. 2-13.
vii Ibid., p. 10.
viii D. Gurney, 'Roman Burials in Norfolk', *East Anglian Archaeology Occasional Paper 4*, 1998.
ix Gurney 1998, 2.
x L. Webster and J. Backhouse, *The Making of England Anglo-Saxon Art and Culture AD600-900* (London: British Museum, 1991).
xi A.-S. Gräslund, 'Thor's Hammers, Pendant Crosses and Other Amulets' in E. Roesdahl and D.M. Wilson (eds.), *From Viking to Crusader* (Paris, Berlin and Copenhagen: Nordic Council of Ministers, 1992), pp. 190-91.
xii Francis Pryor, *Seahenge: A Quest for Life and Death in Bronze Age Britain* (Harper Perennial, 2002).
xiii Artist's statement.

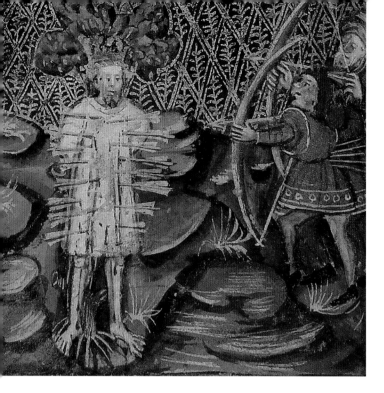

2

ART AND FAITH IN MEDIEVAL NORFOLK

Sandy Heslop

Around the year 1100, all four walls of the nave of the small church of St Mary at Houghton-on-the-Hill, near Swaffham, were covered with paintings (see half-title page). Old Testament scenes dominate the north wall, while to east and west were respectively the Last Judgement and Hell. So far as we know, nothing like it survives from before this period, in Norfolk or anywhere else in England; the spread of large-scale Biblical imagery from the greater churches to isolated rural parishes was a new phenomenon. For this to happen two conditions were fundamental: the Church had to believe in the efficacy of art as a way of conveying religious information, and there had to be a supply of craftsmen sufficiently skilled to produce it. The dramatic upsurge in the production of Christian art at this period was possibly the result of the First Crusade to Jerusalem and of the increasing use of imagery in the contest between the Pope and the Holy Roman Emperor for political control.

The development of an effective public Christian art depended on media which were readily visible, such as stained glass and large-scale sculpture. These also became important around 1100, for example at Norwich Cathedral, where the transept arms were designed with large picture windows, and the north transept exterior has a life-size sculpture of a bishop in the act of blessing placed over the entrance door. This probably represents St Felix, first bishop (c. 630–47 AD) of the East Anglian diocese.

Alongside such imposing displays, smaller scale objects for more limited audiences continued in production. This is evinced by the walrus ivory crucifix reliquary, found in Tombland in Norwich, and the illuminated initial of St Withburga of Dereham for a manuscript copy of her life, written and illuminated at Ely around 1120 (2.6). Together with the new public art, the making and use of more intimate objects and images remained a characteristic of art in the service of religion up to the Reformation of the sixteenth century.

It is significant that Christianity increasingly adopted these visual strategies at a time of unprecedented contact with Muslims (through the Crusade) and Jews. Both Judaism and Islam largely avoided figural representation, taking at face value the Second Commandment not to make imagery. Jews

from cities such as Rouen and Mainz in Continental Europe were in London by around 1090, and a community was established in Norwich within about three decades, remaining until their expulsion from England in 1290. This was the context in which the mysterious death in 1144 of a young apprentice called William, just outside Norwich, was attributed to the Jews by some of his relatives. Within a few years, his body had been 'translated' to Norwich Cathedral, where it remained an intermittent focus of pilgrimage throughout the Middle Ages (2.8).

There were, in fact, three very important sites attracting pilgrims to the region. The longest established was the shrine of St Edmund at Bury (2.5). King Cnut had raised the church with the saint's body to an abbey following the Rule of St Benedict. By 1100 a magnificent new church was nearing completion (the second longest in England – after Winchester Cathedral). However, it was to be the cult of the Virgin Mary at the Augustinian priory of Walsingham that would dominate, being visited by several reigning monarchs, including Henry VIII (3.6). It started in the mid-twelfth century, with a 'copy' of Mary's house at Nazareth but this was soon augmented by a miraculous image of the Virgin and Child. By the 1220s a third relic of importance, a fragment of the True Cross, had been acquired by the Cluniac monastery of Bromholm (2.28–29). Here again the evidence shows early interest, by King Henry III for example, but it was still of considerable importance in the fifteenth century. Such religious centres served to encourage commerce and travel across the region. In this way, the experience of the East Anglian landscape remained closely entwined with individual and collective acts of devotion.

Medieval art and architecture depended to a great extent on the patrons who were prepared to pay for the work. Until the fourteenth century, the main contributors were high-placed and wealthy individuals or institutions. A good example is Bishop Salmon, whose period of office coincided with an astonishing flourishing in the quality and quantity of production. Great manuscripts such as the Gorleston Psalter (2.2) and buildings such as the bishop's great hall and Carnary Chapel in

Norwich Cathedral show an ambition equal with anything being produced elsewhere in England during this period. The diocese of Norwich had clearly become a magnet for the best designers and craftsmen, a situation that was to persist until the Black Death (1349), after which patterns of patronage altered significantly.

The second half of the fourteenth century saw a dramatic transformation in East Anglian society. In the aftermath of the plague, property ownership shifted so that more people of middling status had the means to commission religious art, for example paying for windows in parish churches. Increasing independence may also have served to fuel dissent. The Peasants' Revolt was one consequence; another was the Lollard 'heresy'. Lollards, following the ideas of the Oxford academic, John Wycliffe, held that such things as religious imagery, relics and pilgrimage, were unnecessary to devotion. On their own these might not seem important, but they were part of a package of denial that included the sacraments, the need for priests or churches. So radical and subversive did this seem, that the penalty of death by burning was introduced for heresy in 1401.

In such circumstances, an orthodox member of the community would increasingly have recognised that commissioning or helping to pay for religious images was a way of demonstrating loyalty and obedience to both Church and state. Accordingly, wooden chancel screens were now built with the lower panels divided so as to house painted figures of saints. New fonts were commissioned showing the seven sacraments. Larger windows, again with suitable compartments formed in the tracery, were inserted into the aisle walls of parish churches, to be filled with serried ranks of saints and angels. Church roofs were elaborated with wooden sculptures usually showing angels projecting into space over the heads of the congregation. It may be significant that Wycliffe had criticised the depiction of angels, which he regarded as incorporeal spirits. Thus, by the time of the Reformation, the churches of East Anglia had become in equal measure displays of the wealth and the piety of the Christian community.

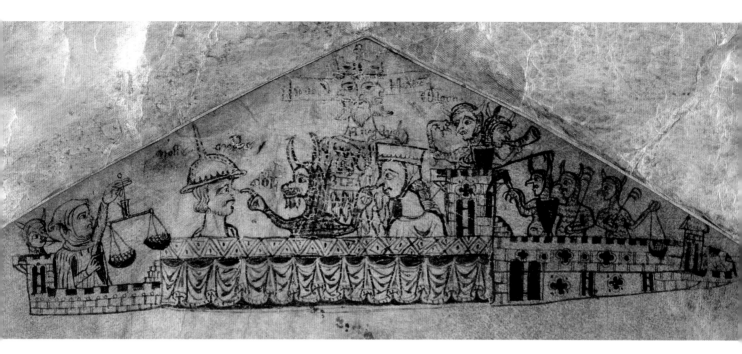

**2.1 CARICATURE OF PROMINENT
NORWICH JEWS**
1232-33
Exchequer roll manuscript
Parchment; 68 x 41.4 cm
The National Archives, UK
E401/1565

This Roll dates from 1232-33, a period of considerable tension between Jewish and Christian communities in Norwich, which culminated in open hostilities in 1235. As the drawing in the Exchequer Roll indicates, money lending was a significant factor. On the left edge of the drawing an apparently Christian merchant holds up scales full of coins, while in the centre a Jewish man and woman appear either side of the devil, who indicates the pointed noses. To the right, on the sinister side of the central figure, there is a 'castle' full of demons. No doubt this alludes to hell but also perhaps to Norwich Castle where the Jews sought the protection of the sheriff and the royal garrison, who are also being vilified here.

2.2 THE TREE OF JESSE

from The Gorleston Psalter, folio 8
Early fourteenth century
Artist unknown
Illuminated manuscript; 37.5 x 27.5 cm
The British Library, Add MS 49622

The Gorleston Psalter is the earliest
of a series of outstanding illuminated
books made in the diocese of
Norwich in the fourteenth century. Its
large scale shows that it was meant to
impress. It already reveals the interplay
of sacred and secular subjects,
with the characteristic hybrids in the
margins and lavish display of heraldry
typical of these works.

 The opening 107v and 108r
bears an initial showing Christ
enthroned surrounded by angels. In
the border a knight raises his shield
towards God, while above a hybrid
with 'street' instruments vies with
the harp, rebec and psaltery of the
angels. Folio 8, illustrated here, shows
a 'Tree' of Jesse in the B initial (of
Beatus vir – Blessed is the man). Christ
appears in that too, at the top of the
tree, but does not appear 'in majesty'.

2.3 PILGRIM
BADGE
from Walsingham,
Norfolk
Late fourteenth
century
Lead alloy
8.7 x 4.9 cm
*Lent by the
Museum of
London*

From the middle of the twelfth century Walsingham was the most important English pilgrimage centre dedicated to the Virgin Mary. The initial focus was a 'copy' of the house in Nazareth where Gabriel visited Mary to announce the Incarnation of God. Subsequently, a miraculous image of the Virgin and Child also became a major attraction. For these reasons Walsingham was particularly visited by those wishing for children, including King Henry VIII.

There are many known types of pilgrim badges relating to this centre, of which the Annunciation is the commonest subject. This late fourteenth-century example in the Museum of London is the largest, best preserved and artistically most ambitious. Recent excavations in Norwich, at the Cinema City site, uncovered a large fragment of the mould in which this badge was cast. This implies that these particular badges were made in the city.

2.4 MONUMENTAL BRASS OF THOMAS CHILDES
Mid-fifteenth century
Attributed to the workshop of Thomas Sheef
Brass; height 56.3 cm
*Norwich Historic Churches Trust (on long-term loan
to Norfolk Museums & Archaeology Service)*

This memorial figure, originally from the Church of St Laurence in Norwich, represents the deceased as a skeleton. The image is derived from the popular story of the Three Quick and the Three Dead. Three princes out riding come face to face with three corpses, each being a version of themselves, and their warning is: 'as you are, so we once were, as we are so you shall be'. In 1970 a version of this story was discovered in a wall painting of about 1360 for the north aisle of the Church of Sts Peter and Paul at Heydon in Norfolk. Another Norfolk brass of this type, of John Brigg, is to be found at Salle, with a similar moral attached.[i]

The principal purpose of such imagery before the Reformation was to encourage members of the community to pray for the soul of the deceased, in order to shorten the soul's time in Purgatory. The deceased were referring to their common humanity to avoid any suggestion of pride in their memorialisation. *AM*

2.5 ST EDMUND
PIERCED BY
ARROWS
1460s
from *The Life of St
Edmund*, folio 48v
John Lydgate
(c. 1370–
c. 1450/51)
Ink on parchment,
gilt leather binding
27.5 x 19.5 cm
*His Grace the
Duke of Norfolk,
Arundel Castle*

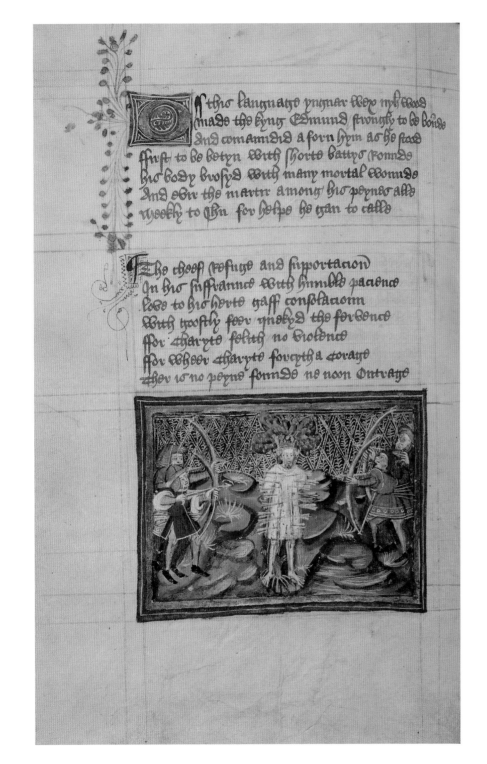

John Lydgate was a monk of Bury St Edmunds. He composed his Lives of Edmund and Fremund at the behest of the Abbot as a gift for King Henry VI in 1433–34. The lavishly illuminated presentation copy made for the King at this period survives in the British Library. Subsequently, in the 1460s, more modest versions, reduced in size and number of illustrations were made in or near Bury for local consumption. The scribe of these books worked on a number of others for patrons in the vicinity. One of them is now in the British Library,[ii] while this slightly larger and better painted example is at Arundel Castle.

The picture of Edmund's martyrdom on folio 48v shows the usual image of the King pierced by arrows. There was a notable revival of interest in Edmund during the mid-fifteenth century, partly as a result of increasing awareness of East Anglia's former status as an independent kingdom, but perhaps also because he had been adopted as a national saint by kings of England, especially Richard II and Henry VI. Moreover, this was a time of political turbulence during which Edmund's cult was a means of showing allegiance to the cause of good government. Edmund's suffering also meant that he could be called on in cases of plague (like Sts Sebastian, Roch and Anthony) at a time when saints were increasingly invoked against physical affliction.

2.6 ST WITHBURGA OF DEREHAM

from *The Life of St Withburga of Dereham, Historia Eliensis,*
folio 59r; 1116–30
Ely priory
Illuminated manuscript; 22.5 x 15 cm
The Master and Fellows of Corpus Christi College, Cambridge

St Withburga illuminates a number of points about the
development of Christianity in pre-Viking East Anglia, 'sacred
theft' and also the continuing importance of a cult even when
the saint's body has been spirited away. The lovely initial on
folio 59r of Corpus 393 is the earliest image that survives of
her. It comes from Ely, where her cult had received a recent
boost thanks to the translation of 1106 and the resulting
enthusiasm of abbot Richard. The style of the drawing retains
the well-known 'vitality' of late Anglo-Saxon art.

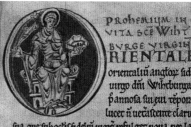

2.7 ST JOHN THE EVANGELIST HANDS THE PALM TO THE JEW

Stained glass from St Peter Mancroft Church, Norwich
Mid-fifteenth century; leaded glass panel; 68 x 48 cm
*Lent by Culture and Sport Glasgow on behalf of
Glasgow City Council*

This is one of a handful of separated panels from one of
the most important mid-fifteenth-century glazing schemes
in Norwich, the Toppes Window from St Peter Mancroft
(c. 1450–55). The scheme contained twenty-five scenes
from the life of the Virgin Mary, including fifteen relating to
her death, burial and assumption. According to legend,
her funeral procession was halted by the Jews, but after
a miracle their leader was converted to Christianity and
St John gave him the palm originally given by Gabriel
to Mary as a token from Heaven to convert other Jews.
The three scenes devoted to this episode show the
importance still placed on this theme in Norwich 150
years after the expulsion of the Jews from England. This
may in part be because now there were also Christian
heretics, the Lollards, questioning accepted beliefs and
practices, including the cult of Mary and holy relics.

Equally significant is the heraldic surcoat worn by
the Jew, which shows the arms of the recently beheaded
Duke of Suffolk. The Duke had been a controversial
figure, causing hostility by his high-handedness and
interference in the lives and businesses of many in the
region. Showing the Jew as a soldier in Suffolk's livery
is a remarkable aspect of the subsequent development,
suggesting accommodation between Norwich citizens
such as Robert Toppes, a former mayor, and their
adversaries. This painted glass panel thus shows how
responsive religious imagery could be to historical
events, whether very recent or centuries in the past. The
painting and design is of the highest quality and, despite
some intrusions, gives an excellent impression of the
compositional characteristics of the period, with the focus
on the faces, gestures and interactions of the main figures.

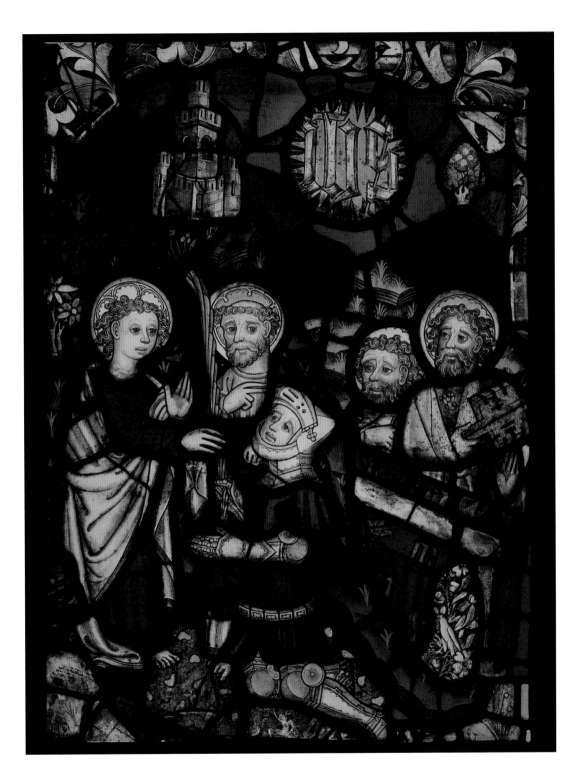

2.8 'ST' WILLIAM OF NORWICH WITH FEMALE SAINT
1450–70
Artist unknown
Tempera on panel; 102.2 x 79 x 1.5 cm
Victoria & Albert Museum

2.9 THE MATLASKE RELIQUARY
c. 1475–1500; Matlaske, Norfolk
Gold with black enamel
3.6 x 2.8 cm
Norwich Castle Museum & Art Gallery

'Saint' William of Norwich died in 1144 in mysterious circumstances in Thorpe Woods. It was claimed by 1150 that he had been ritually murdered by Jews and subsequently that he had been crucified. Although there was a good deal of scepticism, a cult emerged and his body was placed in the north-eastern radiating chapel of Norwich Cathedral (now the Jesus Chapel) in 1154. The shrine was restored in 1325 and there was a 'translation' in 1426, at just the time when the Lollards were threatening orthodox beliefs in relics and pilgrimage. This image was commissioned for the church roodscreen of St John Maddermarket by Ralph Segrym (d. 1471/72), sometime Mayor of Norwich, and bears his initials and merchant's mark.

It is testimony to the revival of the pseudo-saint's popularity as the earliest of the six surviving screen paintings. Although rather damaged, it remains very important, not least because it shows William with a hammer and three nails, in direct imitation of instruments of Christ's Passion. He stands alongside St Agatha or, possibly, Apollonia, an early Christian martyr. The importance of William as a token of hostility between Christians and Jews in the Middle Ages cannot be overstated. The 'William' story became the basis for numerous other false accusations against Jewish communities. It clearly demonstrates how art was used in the rivalry between faiths.

This gold pendant cross was discovered in Matlaske some time before 1852, by a labourer while driving his wagon through muddy ruts.[iii] The cross was originally suspended from the loop at the top, which has almost worn through from use. In fact, it represents only the front and sides to a cross-shaped box which was designed to act as a reliquary, the reverse having been lost in antiquity.

Using an inlay of black enamel to highlight the engraved design, the cross bears the Crucifixion flanked by St John the Baptist and a bishop. John holds the Lamb of God, or *Agnus Dei*, in his left hand while gesturing with his right; the saint-bishop is unidentifiable. Stylistically, this piece dates to the end of the fifteenth century, its engraving finding parallels in the Clare Cross, contemporary iconographic finger-rings, and an enamelled gold sheet with a depiction of the Holy Trinity recently discovered in the Dacorum area of Hertfordshire.

The use of the T-shaped or 'Tau' cross is associated with St Anthony, patron saint of the Order of Hospitallers of St Antoine-de-Viennois, and suggests that it was worn both as an item of personal devotion and as a protection against illness. *TP*

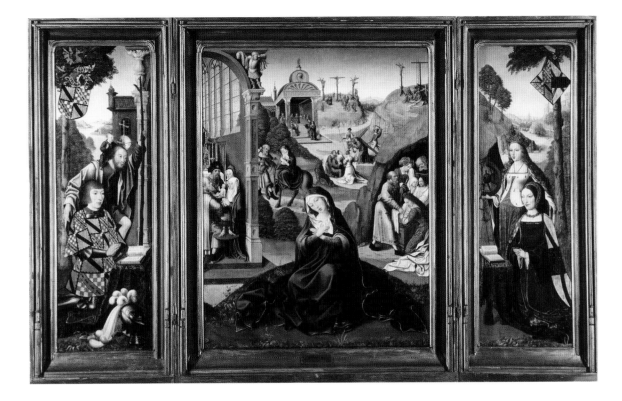

2.10 THE SEVEN SORROWS OF THE VIRGIN

also known as *The Ashwellthorpe Triptych, 1512–20*
Master of the Legend of the Magdalen
Oil on wood; centre panel 83.8 x 64.2 cm,
side panels 83.8 x 26.7 cm
Norwich Castle Museum & Art Gallery

This altarpiece survives as the earliest known commission from a Flemish artist by a Norfolk family and therefore it shows the enduring cultural links between East Anglia and mainland Europe. The name saints on the wing panels, together with the painted arms, identify the sitters as Christopher and Catherine Knyvett. Christopher Knyvett served in the Netherlands in 1512 on a mission to Margaret of Austria and the following year took part in the military campaign which captured Tournai. He was granted lands in Tournai in 1512 and from 1514–20 seems to have received an annual royal salary. He is presumed to have died around 1520 and it is likely that he commissioned the triptych during this period. However, it has also been proposed that the triptych was commissioned by his wife Catherine in his memory.

Catherine's arms suggest that she belonged to a group of families based around Brussels, while their lozenge shape indicates that she may have been a widow at the time of the commission. Such representations were not uncommon at this time and it remains a possibility that she indeed commissioned the altarpiece.

The painter, known for his careful depiction of heraldry, has tentatively been identified as Pieter van Coninxloo of Brussels. His depiction of the Seven Sorrows of Mary as a visual pilgrimage through a landscape is highly original for this period. This, again, suggests that the experience of landscape was closely linked to meditational and devotional practices. The Seven Sorrows are also echoed in the grisaille figure of David lamenting over the head of Absalom featured in the architecture above the Virgin Mary. *AM*

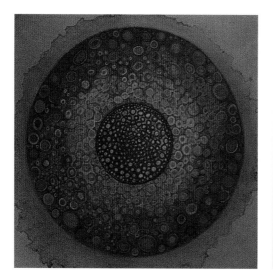

2.11 DARK STAR
2010; Margie
Britz (b. 1949,
Germiston,
South Africa)
Gouache and
found coastal
pigment (mud,
sand, clay,
chalk) on
canvas
122 x 122 cm
Lent by the artist

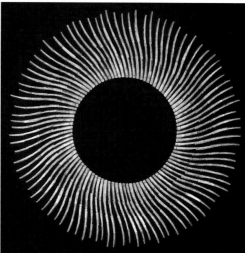

Britz and McGowan have often collaborated and share similar concerns. *Dark Star* and *Eclipse* can therefore be viewed as part of an ongoing dialogue.

Britz, a South African migrant, has made Norfolk's unique landscape her own by engaging with its natural materials but squaring this with the strong sense of pattern found in certain African traditions. Britz has harnessed the properties of carefully selected local stones to make this piece. The stones were strategically laid on canvas and doused with mud and water in order to mimic geological action, leaving deposits akin to glacial flour. The resulting earth-toned debris sheets reveal a sedimentary composition echoing Norfolk's early glacial moraine formations.

The radiating circle, evoking cosmological solar and lunar structures, has been considered powerful since Neolithic times. Significantly, Britz refers to *Dark Star*, with its essential core and radiating periphery, as 'mandala-like'. She invokes the recurrence of this radial form in many types of spiritual representation, from those of mystical Christianity to Tibetan mandalas, from Hindu Yantra diagrams to Islamic sacred geometry. The process of water acting on earth also pertains to the tradition of elemental alchemy. The cosmic-macrocosmic correlation evoked here most strongly recalls the Hermetic Law of Correspondences, epitomized in the words: 'what is below is like that which is above, and what is above is similar to that which is below: to accomplish the miracle of one thing'.[iv] *EAM*

2.12 ECLIPSE
2007; Liz McGowan (b. 1953, Bristol)
Razor-shells on board; 122 x 122 cm
Lent by the artist

Made from razor-shells gleaned from the coastline of Norfolk, *Eclipse* is of the landscape in terms of material, form and title. Through imaginative transformation, these shells have been endowed with new life. When the razor-like casings were arranged in a circle, they revealed a curvaceous tendency that lends vibrancy to the piece. For McGowan, the resultant sun-like rays recall the medieval use of stars on church ceilings, metaphorically uniting heaven and earth. The radial form, expressing the nature of the universe, was also a means by which early Christians tried to contemplate the mystery of Creation. McGowan, like Britz, uses the act of making to pursue natural and personal transformations inspired by alchemy.[v] A central alchemical image is Al, 'the mighty sun' (akin to the Hebrew, *El*), whilst *Eclipse*'s rotary motion also relates to alchemical cosmology. The transformative nature of the making process continues through spiritual engagement with the beholder. *EAM*

2.13 THREE PAPAL SEALS CONVERTED
TO AMULETS,
Twelfth–fifteenth century
Lead; c. 3.8 cm (max. dimensions)
Norwich Castle Museum & Art Gallery

2.14 JEWISH RITUAL VESSEL (THE BODLEIAN
BOWL), Thirteenth century
Probably France
Bronze; height 25 x diameter 25 cm
*The Ashmolean Museum, Oxford. Transferred
by the Bodleian Library 2006*

2.15 PILGRIM BADGE MOULD,
Fourteenth century
Norwich
Soft stone; 6 x 4 cm
*Norfolk Museums & Archaeology Service
(NAU Archaeology)*

2.16 SUB PRIOR'S SEAL,
Fourteenth–fifteenth century
West Acre, Norfolk
Silver; 3 x 2 cm
Private collection

2.17 BAPTISMAL FONT COVER,
Fifteenth century
Castle Acre, Norfolk
Polychromed wood; height 400 cm approx.
Church of St James the Great, Castle Acre

2.18 CLERICAL COPE
Fifteenth century with nineteenth-century hood
Church of St James, Pockthorpe, Norfolk
Embroidered silk and velvet; 145 x 205 cm
*Carrow House Costume & Textile Study Centre,
Norwich*

2.19 THE RANWORTH ANTIPHONER
Fifteenth century
Illuminated manuscript; 52.7 x 37.6 cm
Church of St Helen, Ranworth, Norfolk

2.20 PANEL OF ST MARGARET OF
ANTIOCH, c. 1420/30
Church of St Michael-at-Plea, Norwich
Oil on panel; 101 x 43.8 cm
The Dean & Chapter of Norwich Cathedral

2.21 ALABASTER ALTARPIECE PANEL
DEPICTING ANGELS, Mid-fifteenth century
Church of St Peter Mancroft, Norwich
Alabaster and pigments; 50.4 x 25.4 cm
The Dean & Chapter of Norwich Cathedral

2.22 ALABASTER ALTARPIECE PANEL
DEPICTING VIRGINS, Mid-fifteenth century
Church of St Peter Mancroft, Norwich
Alabaster and pigments; 40.5 x 28 cm
Church of St Peter Mancroft, Norwich

2.23 ALABASTER ALTARPIECE PANEL
DEPICTING APOSTLES, Mid-fifteenth century
Church of St Peter Mancroft, Norwich
Alabaster and pigments; 32.5 x 28 cm
Church of St Peter Mancroft, Norwich

2.24 ALABASTER ALTARPIECE PANEL
DEPICTING PROPHETS, Mid-fifteenth century
Church of St Peter Mancroft, Norwich
Alabaster and pigments; 40.7 x 27.3 cm
Church of St Stephen, Norwich

2.25 STATUE OF ST CHRISTOPHER
Fifteenth century
Terrington St Clement, Norfolk
Clunch stone; 155 x 44 x 26 cm
Church of St Clement, Terrington St Clement

2.26 MEMENTO MORI PORTRAITS, 1480s
Sparham, Norfolk
Polychrome panel; 126.5 x 140 x c. 23 cm
Church of St Mary, Sparham

2.27 PILGRIM SOUVENIR IMAGE OF THE
BROMHOLM ROOD, Fifteenth century
The Lewkenor Book of Hours
Bromholm Priory, Norfolk
Ink on vellum; 16.2 x 12 x 5.7 cm
*By Courtesy of the Trustees of Lambeth Palace
Library*

2.28 PILGRIM PRAYER ROLL,
Early sixteenth century
Bromholm Priory, Norfolk
Ink on vellum; c. 132 x 20 cm
Private collection

2.29 THREE PILGRIM TOKENS,
Medieval
Bromholm Priory, Norfolk
Lead alloy; diameter 2.5 cm
Norwich Castle Museum & Art Gallery

2.30 TWO VOTIVE ITEMS: PLAQUE AND
POSSIBLE CROWN OF THORNS,
Medieval
Bromholm Priory, Norfolk
Lead alloy; 6 x 2 cm, diameter 1 cm
Norwich Castle Museum & Art Gallery

Notes
i R. Greenwood and M. Norris, *The Brasses
of Norfolk Churches* (Woodbridge: Boydell
Press, 1976), p. 22.
ii Yates Thompson MS 47.
iii R. Fitch, 'Engraving of a Gold Niello, Found
at Matlask, Norfolk' *Norfolk Archaeology* 3,
1852, pp. 97–104.
iv The Smaragdine of Hermes Trismegistus,
line 2, in J. Everard (trans.), *The Divine Pymander
of Hermes Mercurius Trismegistus* (London: T.
Brewster and G. Moule, 1650).
v See Theoprastus Paracelsus, *Paragranum*,
1565.

3

CATHOLICS, PROTESTANTS AND STRANGERS

Margit Thøfner

In 1538 King Henry VIII of England ordered the destruction of the great pilgrimage shrine at Walsingham in north Norfolk. The opulently decorated sanctuary dedicated to the Virgin Mary, the most important pilgrimage centre in England, was to be no more. By such iconoclastic acts, by dismantling certain types of ecclesiastical art and architecture, the King made explicit his support for the religious movement we now call the Protestant Reformation. From the very beginning, the Reformation was about art. Or rather, it was about whether art might help or hinder worship.

The consequences, however, were not obvious. In some contexts the traditional, Christian reliance on the arts continued, in others it was considered profoundly ungodly. Forged out of this paradox and, in part, out of print culture, there gradually emerged a new, distinctly Protestant artistic vocabulary.

By the late 1520s the notion that the Christian Church was in need of root-and-branch reform began to circulate in earnest across the European Continent, a notion developed by Protestant theologians like Martin Luther, John Calvin and Huldrych Zwingli. These reformers had different attitudes to art,

varying from toleration to prohibition, but they all shared the fear that imagery might inspire idolatry rather than aid worship. This fear was hardly new: in England it resonated with earlier calls for reform associated with the Lollards.

What was new was that, across northern Europe, the calls for reform were backed by a number of princely champions, usually with the hope of gaining political advantage. In the 1530s, the process that would call the Church of England into being was set in train when Henry VIII broke with the Papacy and with Rome, in part so he could divorce his first wife, Catherine of Aragon (3.6). This process was not straightforward: links with Rome were restored during the reign of Mary Tudor, Henry's daughter from his first marriage, and then broken again under his second daughter, Elizabeth I. Elizabeth then presided over the formulation of a distinctly Anglican theology, essentially a moderate version of the teachings of John Calvin, which still forms the basis of the Church of England today.

Besides all of this, in the first half of the sixteenth century, reformed attitudes to art spread across Europe with

unprecedented speed. This was due to an important new technology: the printed book and, with it, the circulation of printed imagery in a volume hitherto unknown. By the mid-fifteenth century, the production and consumption of books had already reached a new peak across Europe – so the importance of the printing press should not be exaggerated. As an invention, it simply enabled the rapid expansion of an already substantial existing market. It was as if the inhabitants of Europe, especially those in cities, could not get enough of reading. And their favourite subject was the Christian religion: the majority of books in circulation were either devotional or theological in nature. In this manner, the message that the Christian Church needed substantial reform quickly found an attentive audience. By the end of the sixteenth century, every parish church in Norfolk and across England owed at least two books: one was an English translation of the Bible, duly authorised by royal fiat, and the other was John Foxe's 'Book of Martyrs' (3.9). The illustrations in these books served as the basis for a new, Protestant imagery which pictured the reformed religion as embattled, under constant threat from the forces of the 'Popish' Antichrist.

In practical terms, in the diocese of Norwich, the consequences were profoundly divisive. In rural Norfolk, in particular, there was a substantial body of so-called Recusants who – despite crippling fines and occasional but vicious persecution – remained faithful to Rome and to the traditional forms of Christianity as developed in the fourteenth and fifteenth centuries. For example, at Oxburgh Hall, the Bedingfeld family kept up Roman Catholic forms of worship as best they could, with as many of the traditional accoutrements, such as golden chalices and rich vestments, as could be managed under the circumstances (3.12 and 3.13). On the other side, mainly in urban settings, especially in Norwich, there were groups of radical Protestants who saw the Elizabethan settlement as a feeble compromise. In

the last third of the sixteenth century this point of view was given numerical reinforcement when Flemish Calvinists, known as 'the Strangers', were permitted to settle in Norwich. Many of these had fled religious persecution in the Low Countries; their devotion to reformed worship was, for some, a matter of life and death. In Norwich, where they were granted the use of the present-day Blackfriars Hall, the Strangers continued their patterns of worship, favouring simple, whitewashed interiors centred on preaching. This caused a certain amount of friction: the Strangers' Church was a constant reminder that there were types of reformed Christianity far more radical than the Anglican version. Certainly, Anglican worship was also focused on preaching, and in the course of the sixteenth century, many Norfolk parish churches, including the former priory at Binham, were 'purified' or redecorated so that the interior was dominated by the Biblical Word rather than angels or saints (3.8). Even so, the Elizabethan settlement allowed for the use of music, rich chalices and opulent vestments during communion service if the local parish community favoured it. For this reason, especially in rural Norfolk, there survives to this day a significant body of medieval works of art, especially of medieval church silver, precisely because the local communities refused to do away with them.

One thing remained constant on either side of the confessional fence: as in the medieval period, public religious art was fundamentally the domain of the rich and the powerful. Local aristocrats and the urban elites continued to commission impressive funerary monuments for themselves and their families, monuments which can still be seen in many parish churches. On the other hand, possession of an illustrated book like Foxe's 'Book of Martyrs' was certainly within the reach of the artisanal classes. Because of the coming of print, it was now possible for anyone with a little bit of disposable income to make their religious allegiance clear through the ownership of imagery.

3.1 COMMUNION CUP AND PATEN-COVER

c. 1540–68
William Cobbold of
Norwich, or London
Silver-gilt; 17.8 x 9.5 cm
St Andrew's Church, Norwich

This cup, with its fine decorative
detail, was originally a secular
goblet which was acquired
by St Andrew's Church as
a communion cup. The
change of use is indicated
by the spool-shaped foot on
the paten which is typical of a
paten cover of this date and replaces the original knop, which
would have been ball-shaped or figurative. William Cobbold,
whose maker's mark is stamped on the rim of the cup, was a
prominent Norwich goldsmith, but the attribution of this object
to him is not certain. The form and decoration of the goblet are
highly unusual for English work. Only two other similar pieces
are known, one of which is in Wood Dalling Church, also in
Norfolk. This very similar cup bears clear London hallmarks
of 1531–32. It has been suggested either that Cobbold may
have donated a London-made cup to his own parish church
of St Andrew, but added his own mark to signify his donation,
or that he used the Wood Dalling cup as a model to make
this one.

Whatever its provenance, this magnificent object, given
to St Andrew's in 1568 soon after the establishment of the
Norwich assay, exemplifies the expedients undertaken by
many churches during this period. In 1565 the order had
gone out from Archbishop Parker to replace all chalices with
a 'seemly communion cup', to mark the changed status of
the sacraments. Rather than make new cups, many churches
adapted existing silverware, leading to the creation of many
interesting and attractive hybrids. *FV*

3.2 COMMUNION BEAKER

c. 1575–85
William Cobbold,
Norwich
Silver; 17.8 x 9.5 cm
*Norwich Castle
Museum & Art
Gallery*

This beaker is one of
a set of four made
for the 'Strangers'
Church' in Norwich by
William Cobbold, a local goldsmith. The use of beakers
to hold the wine during the Lord's Supper was a Calvinist
practice and there is a strong contrast with the single-
stemmed communion cups used in the Church of England
during this period.

The beakers may have been made on the initiative of
the Dutch goldsmith George Fenne. He was the warden
of the Dutch Goldsmiths in Norwich, the leading Elder
of the Dutch Congregation and William Cobbold's
son Matthew was apprenticed to him. However, each
beaker is inscribed 'GIFT OF MR RYCHARD BROWN
OF HEIGHAM', showing that they were donated by
Richard Brown, who would subsequently become Sheriff
of Norwich. Brown had no official connection with
the Dutch Church but his gift indicates the continuing
relationship of politics and religion.

The graceful form of the beakers and the engraved
bands of strapwork with stylised flower and foliage motifs
testify to Cobbold's considerable skills as a goldsmith
and also to the understated elegance favoured by the
affluent Dutch Congregation in Norwich. [Entry prepared
with thanks to Diana Gratton and Francesca Vanke].

3.3 PORTRAIT OF ROBERT JANNYS

Unknown artist
Early seventeenth-century copy
of a sixteenth-century original
Oil on panel
77.5 x 61 cm
*Norwich civic portrait
collection*

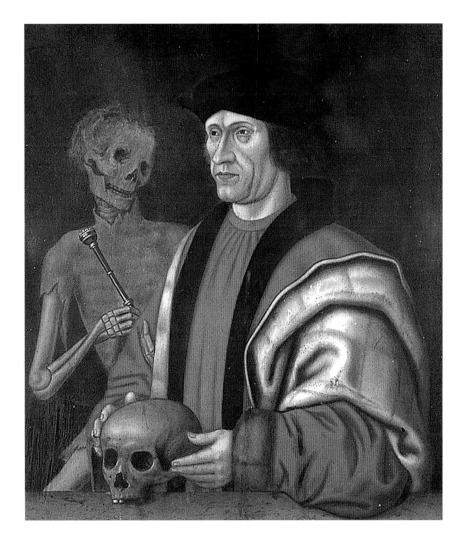

The Norwich alderman Robert Jannys, who died in 1530, was one of the richest merchants in the city. He is known chiefly for the generous bequests set out in his will. These included providing dowries for poor brides and also the distribution of alms to eighty poor persons every Friday for twenty years after his death.[i] Evidently, late medieval patterns of piety, whereby good works were thought to open the gates of heaven, continued well into the sixteenth century.

This portrait of Jannys forms part of a set belonging to the city of Norwich. He was most likely included so that subsequent colleges of aldermen might be inspired by his virtues, as indicated by the inscription, which ends: 'for Jannys[,] prayse god[,] I pray you all, whose acts do remayne a memoriall'. Certainly, both image and inscription may be derived from a now lost stained-glass window originally set in the council chambers of the Norwich Guildhall.

Jannys is shown in rich, fur-lined robes of office but with his hands on a skull. This reminder of aldermanic mortality is repeated in the ragged skeleton behind him, who serves as his tipstaff. Thus the image belongs to a well-established tradition, in which riches and social status are represented as transient (see, for example, 2.4).

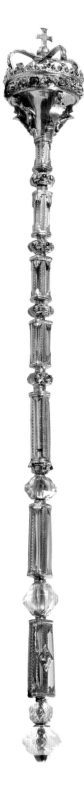

3.4 CRYSTAL MACE

c. 1550

Maker unknown

Gold, rock crystal, gem stones

98.8 x 11.7 cm

Norwich City Council Civic Regalia Collection

This imposing object was given to the Norwich City Corporation by Augustine Steward, alderman, thrice mayor and Member of Parliament for Norwich. Its purpose was undoubtedly to underscore the dignity of public office by being carried in procession before the mayor and the college of aldermen. By 1550 Norwich was becoming a predominantly Protestant city. Yet the imagery on this mace, with the four dragons supporting the crown, harks back to pre-Reformatory traditions, specifically to the pageants which usually marked St George's Day in Norwich. These usually included a splendid dragon and this, in turn, was to mark the fact that the St George's Guild was the most powerful, late-medieval body within the city. By the late sixteenth century, the yearly celebrations of this prestigious guild had merged with the annual inauguration of the new Lord Mayor.

It is also noteworthy that the crown at the top of this mace is topped by an orb surmounted by a cross. This is a conventional symbol of power, suggesting that the whole globe is dominated by Christianity. Such explicit religious references on a fundamentally civic object show how closely the sacred and the political were entwined in sixteenth-century Norwich.

3.5 COMMUNION CUP, FROM CHURCH OF ALL SAINTS, HETHEL

Jan van Hauweghem, 1532

Ghent

Silver; 12 x 9.8 cm

Norwich Castle Museum & Art Gallery

In 1907, this silver cup was described as having served 'a long time' as a chalice in the parish church of Hethel.[ii] It is, in fact, for domestic use and, as the hall-mark and maker's mark indicate, the cup was originally made in the Flemish city of Ghent in present-day Belgium. At some point in its existence, most likely in the wake of the Reformation, the cup was brought from the Low Countries, perhaps by one of the 'Strangers', and eventually it ended up becoming a chalice in Hethel. As such, it recalls the enduring cultural links between Norfolk and the Low Countries. Yet it also suggests that, in response to reformed thinking, some Norfolk parishes tried to demystify the taking of communion by making it appear more like a secular meal. Certainly, in the sixteenth century, receiving communion wine from this cup would have seemed akin to drinking wine at an elegant dinner party.

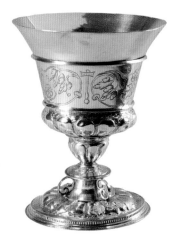

3.6 CATHERINE OF ARAGON WITH A MONKEY

c. 1525
Lucas Horenbout
(1490/95–1544)
Miniature, vellum on card
5.5 x 4.8 cm
Trustees of the 9th Duke of Buccleuch's Chattels Fund

This magnificent portrait from life is by Lucas Horenbout, court artist to Henry VIII and recognised as the father of the English school of portrait miniatures. It is one of the most important of Catherine to survive. As an historical figure, Catherine stands at a pivotal point in time in terms of the history of religion in England. She represents the old order of traditional Catholic devotion just at the point when, ironically, due in part to hers and Henry's unfortunate inability to bear a living son, her husband was about to break with Rome and change English religious practice forever.

Catherine had a strong connection with the shrine of Our Lady of Walsingham in north Norfolk. This was one of the most revered pilgrimage sites in England prior to the Dissolution of the monasteries, and certainly the most prominent Marian shrine in the country. Catherine went on many pilgrimages to Walsingham, both with Henry VIII and alone.

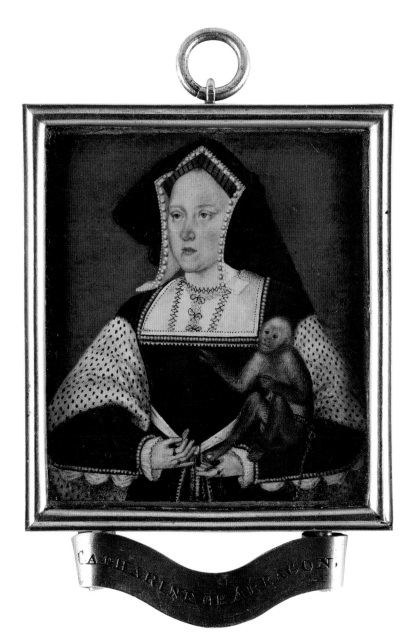

She had a special reverence for this shrine, probably because it was traditionally visited by women wishing to bear sons. When she died in January 1536 Catherine left instructions in her will that someone should go on a Walsingham pilgrimage on her behalf, distributing '20 nobles' (about £16) to the poor en route. Given that the priory at Walsingham had begun to be dissolved by the summer of 1536, it is unknown whether this was ever carried out. *FV*

3.7 PORTRAIT
OF ST PHILIP
HOWARD,
AGED 18
1575
George Gower
(c. 1540–96)
Oil on panel
47 x 36.8 cm
*His Grace the
Duke of Norfolk,
Arundel Castle*

3.8 ROOD SCREEN PANEL 'THE RISEN
CHRIST', WITH ICONOCLASTIC DEFACING
c. 1540–53; Artist unknown
Oil on board; 106.5 x 45.8 cm
*The Priory Church of St Mary and the Holy
Cross, Binham, Norfolk*

Philip Howard was the son of Thomas Howard, fourth Duke of Norfolk, and his wife, Lady Mary FitzAlan. However, due to his father's support for Mary, Queen of Scots, Philip never acceded to the title of Duke of Norfolk; he only inherited his mother's estate and thus became Earl of Arundel. Philip was baptised as a Catholic but nevertheless raised as a Protestant; he was partly educated by John Foxe (see 3.9) and then at Cambridge University, at this point in time a bastion of Protestant theology. However, from 1581 onwards he became increasingly attracted to his baptismal faith, in part due to the agency of his wife Anne Dacre. Philip formally converted to Catholicism in 1584 and the following year he sought to flee England so he could practise his beliefs freely. However, he was captured, arrested and imprisoned in the Tower of London for treason, where he remained until his death in 1595, steadfastly refusing to abjure his faith. For the substantial minority in East Anglia who remained faithful to Catholicism, Philip's life and death must have been a welcome rallying point. That, in part, was because of his social and political prominence: the Dukes of Norfolk were ranked as the first peers of England.

This portrait shows Philip Howard as a young man, while he was still a Protestant. However, the severe colour scheme of the portrait should not be understood as a statement of faith; rather, with the quietly opulent lace-collar, it reflects Spanish court fashions of the period and therefore indicates the sitter's high rank. The artist, George Gower, went on to become Elizabeth I's Serjeant Painter in 1581. This, again, indicates the elevated circles in which young Philip Howard moved and shows just how much he would later forfeit for his faith.

This panel from the Binham rood screen is a dramatic testament to iconoclasm. At some point in the sixteenth century it was painted over with texts from the Tyndale and Coverdale Bible editions. This shows how, in the Elizabethan Reformation, the Word came to replace sacred images. Rood screens usually divided the nave from the chancel and, in the later Middle Ages, the decorations on them were explicitly designed to address the laity. As the Reformation got under way, there was a strong sense amongst Anglican theologians that such imagery might well corrupt ordinary Christians by inviting their worship and thus making them into idolators. Instead, the laity was now to behold the Word of God in plain English. Sacred text triumphed over sacred image.

Time, however, has overtaken such concerns. The process whereby Christ's face was replaced by the Word has been gradually revealed by flaking whitewash. The imagery emerging behind the texts assume a haunting poignancy never originally intended, their coexistence a mere chance of history. These panels therefore present a vivid juxtaposition of two of the more extreme approaches to religious pictures which characterised the Reformation.

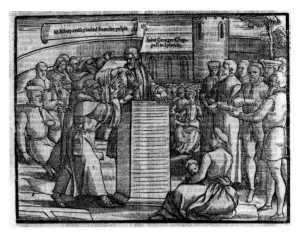

3.9 JOHN FOXE, 'BOOK OF MARTYRS' 1583
John Foxe (1516–87)
Printed book
(John Day)
39 x 24.7 cm
Senate House Library, University of London

This book, first issued as *Rerum in ecclesia gestarum... commentarii...* but better known under its English title of *Actes and Monuments of these latter perillous dayes...* (1559), is a vitally important document in the history of the Reformation in England; by the end of the sixteenth century virtually every parish church in the country owned a copy. Its vivid descriptions of suffering and martyrdom mingled with graphic woodcuts made it one of the most popular and successful pieces of anti-Catholic propaganda ever produced in the British Isles. It is most likely due to this book that Mary Tudor became known as 'Bloody Mary'. The book is also of particular interest because it contains references to and illustrations of important Catholics from East Anglia who were connected with Mary's counter-Reformation and therefore vilified by Foxe. These include Suffolk-born Stephen Gardiner, Bishop of Winchester, Sir Henry Bedingfeld of Oxborough who was the jailor of the future Queen Elizabeth during Mary's reign, and the infamous Bishop Edmund Bonner of Dereham, Mary's fiercest supporter in the campaign against 'heresy'.

This illustration shows Norfolk-born cleric Thomas Bilney (c. 1495–1531) being dragged from his pulpit. An early martyr of the Reformation, he was burned at Lollard's Pit in Norwich, where adherents to the 'heretical' Lollard movement had been burned in the previous century. Many Protestants were to die there under Mary Tudor in the years following. These events show very clearly how dangerous it was in the sixteenth century, for both Catholics and Protestants alike, to dissent from whatever was the current, state-sponsored religious ideal.

Foxe's anti-Catholic tirades had an enduring impact. Although outright persecution of Catholics ceased by the mid-seventeenth century, right up until the beginning of the nineteenth century, there was a widespread sense that being an English Catholic was a contradiction in terms. In Norfolk, where a substantial Catholic minority continued to practise, this must have caused a great deal of friction and hurt.

3.10 LOSS OF FACE,
ICONOCLASTS, ZEALOTS
AND VANDALS
1992–2002
John Goto (b. 1949,
Stockport); with
electroacoustic soundtrack,
Ludham bells, by Michael
Young (b. 1968, South
Shields)
Rescaled monochrome
photographs in etched steel
frames
Eight panels,
each 127 x 102 cm
Lent by the artist

This diptych, part of Goto's *Loss of Face* series, draws upon 'forensic' photographs of Norfolk's defaced rood screens. Goto notes the selective attacks on these faces: some had their eyes gouged and their mouths plugged, some were viciously scratched whilst others remain untouched. He is intrigued, too, by the prevalence of preserved screens in Norfolk churches when those of other regions were simply ripped out. Perhaps, as Goto speculates, these violated faces were left as warnings to those unwilling to embrace the Reformation. Rescaled and presented in jagged, chevron-etched frames reminiscent of Norman church decorations, Goto's images emphasise the fear and violence that attended iconoclasm. Or, he wonders, maybe the paintings inspired awe in those who attacked them, even as they attempted to demystify the images by revealing the base wood beneath. The Calvinist Reformation involved a deobjectification of faith and a demystification of the Church with new weight placed upon individuals and their relationship to God. As Goto sees it, iconoclasm also released art from its mysticism. For him, these images contain human conflict, in all its forms, as it persists into the present day.

The accompanying soundtrack, inspired by the pealing bells of the Church of St Catherine at Ludham, is by Michael Young, Senior Lecturer in Music at Goldsmith's, University of London. The five bells intone a series of melodic patterns; each one is underpinned by a slower version of itself, alluding to the medieval practice of mensuration canon. *EAM*

3.11 CHALICE CASE, c. 1330
Cawston, Norfolk
Tooled, boiled leather; 24.5 x 22.5 cm
Church of St Agnes, Cawston

3.12 BEDINGFELD CHALICE AND PATEN
1518–19
Unknown artist, London
Silver gilt, enamel
Chalice height 15.2 cm; Paten diameter
13.1 cm
Victoria & Albert Museum

3.13 BEDINGFELD CHASUBLE
Mid seventeenth century
Textile, with nineteenth-century restoration
100 x 75 cm approx.
Henry Paston-Bedingfeld of Oxburgh Hall,
Norfolk

3.14 PORTRAIT OF THOMAS HOWARD, 4TH
DUKE OF NORFOLK, 1565
Unknown artist
Oil on panel; 117.3 x 84.8 cm
Ancient House Museum, Thetford

3.15 'ST PETER'S COMPLAINTE', WITH
OTHER POEMS (1595)
Robert Southwell (d. 1595)
St Omer edition, 1620
14.8 x 8 x 3.4 cm
By kind permission of the Syndics of Cambridge
University Library, Syn.8.63.415

3.16 COMMUNION CUP AND COVER
1567–69
William Cobbold, for church of St Mary
Coslany, Norwich
Silver
Cup 16.7 x 11.1 cm; cover 4.2 x 13.1 cm
Norwich Castle Museum & Art Gallery

3.17 PORTRAIT OF ARCHBISHOP MATTHEW
PARKER, Seventeenth century
Unknown artist, after engraving by Remigius
Hogenberg, 1572
Oil on panel; 61 x 49.5 cm
Norwich civic portrait collection

3.18 COAT OF ARMS OF ELIZABETH I
Late sixteenth century
Church of St Mary, Preston, Suffolk
Oil on panel; 193 x 117 cm
Church of St Mary, Preston

3.19 SOUTH PROSPECT OF BLACKFRIARS
CHURCH IN NORWICH,
Mid seventeenth century
Attrib. Daniel King (d. 1664?)
Engraving; 17.3 x 29 cm
Norwich Castle Museum & Art Gallery

Notes

i Norman Tanner, 'Religious Practice', in
Rawcliffe, C. and Wilson, R., (eds.), *Medieval*
Norwich (Hambledon and London, London and
New York, 2004), p. 150.
ii C.C. Oman, 'The Hethel Communion cup',
Norfolk Archaeology, vol. 31, 1957, p. 197.

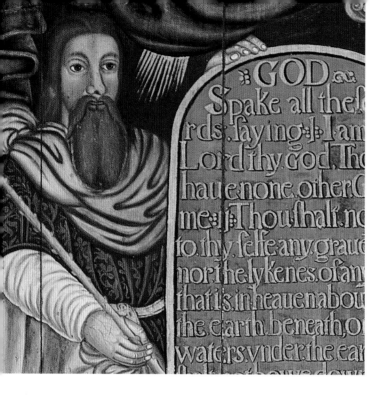

4

LAUDIANS, PURITANS AND WITCHES

Francesca Vanke

Religious life in Norfolk during the first half of the seventeenth century was characterised by bitter strife between radical Puritans and Laudian Anglicans. Followers of Archbishop William Laud rejected John Calvin's doctrine of predestination, hitherto the basis of English Protestantism. Calvin had taught that those destined to enter Heaven had already been chosen by God, meaning that people's deeds in life would ultimately make no difference to whether they were bound for Heaven or Hell. Laudians disagreed with this and, besides, they approved of 'high' church practice, with elaborate rituals and trappings. Believing in the divine right of kings, Laud and his adherents were also staunch supporters of Charles I. All this was in absolute opposition to the austere beliefs and practices of the Puritans, who suspected that idolatrous 'papistry' was creeping back.

In Norfolk, a county with strong Puritan traditions, conflicts were exacerbated by the appointment of a hard-line Laudian, Matthew Wren (4.2), to the bishopric of Norwich in 1635. Wren attempted to regulate the diocese along Laudian lines. This included reconfiguring churches and reinstating rails to restrict access to the high altar. The laity would kneel at the rails to receive communion, only the clergy being permitted to enter the sanctified area before the altar. This was in contrast to Calvinist custom, where the altar was placed centrally so all could approach it. Wren's move was highly unpopular. Many individuals saw it as a return to pre-Reformatory practice which emphasised hierarchies between clergy and laity and focused on the Sacrament rather than the Word of God. Wren banished or excommunicated clergy who refused to conform. Some of these fled to the Continent.

In turn, Laudians were ousted after the outbreak of civil war. Laud himself was beheaded and Wren imprisoned. Norfolk did not suffer as much during this war as some English regions but still had to contend with religious riots, severe taxation and natural disasters including plague, floods and harvest failures. In 1643, a law was passed condemning religious images in churches as idolatry. Norwich Cathedral became a particular focus for Puritan anger because it was strongly associated with Bishop Wren. The cathedral was ransacked and glass, pictures, brasses, crucifixes and furnishings publicly destroyed.

Fearing that current events were a judgement from God against sinful humanity, in an upsurge of religious zeal many people looked for scapegoats. It was in this unhappy climate that the Puritan Matthew Hopkins, probably from Suffolk, rose to prominence (4.5). Little is known of his background but he seems to have been on a single-minded mission to purge East Anglia of what was considered a mortal sin: witchcraft.

Belief in witches as servants of Satan and practitioners of evil was near-universal in this period. Nonetheless witch-hunting was a sporadic, small-scale activity in England when compared with Scotland, or mainland Europe. Hopkins, who styled himself the Witchfinder General, was responsible for what became the most sustained, systematic witch-hunt ever undertaken in England. Between 1644 and 1647 Hopkins and his assistants scoured East Anglia. No-one knows how many people were executed as a result, but estimates vary between 100 and 400. The accused were usually poor, unpopular, elderly, sometimes disabled, disfigured or living alone with animals – or possessing some other trait which aroused fear and suspicion.

Hopkins was initially welcomed. People believed destroying witches would please God and purify society. Eventually however, the financial consequences caused increasing concern. Apart from costs incurred by legal procedures, prisons and executions, Hopkins and his associates received approximately £1 per conviction, a substantial sum for the time. Some also became suspicious that since Hopkins appeared to know so much about witchcraft (he found witches without fail wherever he went) this implied he himself was in league with the Devil. By 1647, public opinion had turned against him.

After the Restoration of the monarchy in 1660, ideas about religion were in flux. Laws were passed re-establishing the supremacy of the Church of England because Parliament, hoping to prevent another civil war, was trying to contain the potentially politically destabilising implications of nonconformity. Paramount was the need to ensure that no-one could undermine loyalty to the Crown by questioning the King's role as Head of the Church. The continued prominence of royal coats-of-arms in churches was a reminder of enduring links between loyalty to God and to the monarch. (4.6)

Despite this, there was a gradual move towards increasing religious freedom. Norfolk was a focal point for many different kinds of nonconformity, including Presbyterians, Baptists and Quakers as well as the 'Stranger' Dutch and French churches. These groups were relatively small numerically but nevertheless represented a significant force in the community. However, anyone standing for public office was obliged by law to conform to Anglican convention, and some did attend both Anglican and Nonconformist services but in practice infringements were seldom prosecuted with any severity. It is likely that, in the aftermath of war, the authorities were more concerned to foster civic unity than court further division in cases where religious practice actually constituted no political threat.

To contemporary eyes Quakers stood out as extremists: a source of suspicion to Puritans and other Protestants alike. Quakers were uncompromising in their dress, behaviour and in their refusal to declare loyalty to any but God, which meant they would not swear the official oath of allegiance to the state. Many were harassed and imprisoned but remained an important minority in Norfolk.

Before 1700 all forms of Protestantism were practised freely. By contrast, anti-Catholic feeling was still strong and Catholics would have to wait another century for full tolerance. The 'Glorious Revolution' of 1688 had deposed Catholic James II in favour of his Protestant daughter Mary and her Dutch husband William. Their Act of Toleration in 1689 permitted freedom of worship to all Nonconformists who swore the oath of allegiance and whose preachers were licensed.

In both Norfolk and Suffolk, increasing tolerance was reflected in the building of official Nonconformist places of worship. Characteristically independent, seeing themselves as needing no earthly sanction, the Norwich Quakers' first Meeting House was founded in 1679. Soon after 1689 the first Presbyterian chapel appeared, later replaced by the imposing Octagon Chapel. By 1693 what is today known as the Old Meeting House was built (4.9) – one of the oldest surviving Nonconformist places of worship in the country. In Suffolk, chapels were built in Ipswich and in Walpole. This shows that England was now firmly established as a Protestant state.

4.1 ROUNDEL FROM
PRESTON HALL, SUFFOLK
c. 1600
Stained glass
Diameter 20 cm
Victoria & Albert
Museum

From the
Reformation onwards
stained glass making
declined in England,
due to increasing
focus on the Word in the
Christian liturgy. During the Civil
War, the law forbidding all images
in churches meant that very little stained glass
was made even though some was still commissioned for private houses.

This roundel was made for the home of the well-known Puritan
antiquarian and cleric, Robert Ryece (1555–1638), of Preston Hall, near
Lavenham, Suffolk. It epitomises Puritan attitudes regarding acceptable
imagery. A moralising verse is accompanied by symbols of human
mortality: a skull, hourglass and candle, with a book, presumably the Bible,
in the centre.

There is, however, more to the design of this roundel than meets the
eye. The quotation 'Vitae Immortalis Studio Mors Temnitur Atra' ('Dark
Death is disdained by the desire for eternal life') is not from a Biblical
source but from an Italian emblem book called Symbolicarum Quaestionum
de Universo Genere by Achilles Bocchius, published in 1555. Emblems
were images illustrating proverbs and moral precepts, usually accompanied
by erudite references to classical sources. In Bocchius's original work this
quote was accompanied by quite a different image: the Greek philosopher
Cleombrotus falling to his death while reading. This event was the subject
of an epigram by the poet Callimachus, to which the emblem book refers.

The message – of the need to be ready for death which might strike
at any time – is similar, but on the roundel the illustration has been altered
to make it more appropriate to a Protestant, Puritan ethos. Through the
combination of word and image Ryece has demonstrated both classical
learning and religious orthodoxy.

4.2 MATTHEW WREN
English School; c. 1615–20
Oil on canvas; 74 x 62 cm
By kind permission of
the Master and Fellows
of Pembroke College,
Cambridge

Matthew Wren (1585–1667),
Bishop of Norwich 1635–38,
was one of the most
significant religious figures of
the period. This portrait is the
only surviving image taken
from life. Wren was one of
the most trusted supporters
and advisors to both Charles
I and Archbishop Laud
and his appointment to the
huge, notoriously difficult
diocese of Norwich was
an acknowledgement of
his abilities and his tireless
determination. He soon
became highly unpopular
however, as he scrutinised
every aspect of religious life,
liturgy and practice in minute
detail, making every possible
effort to enforce conformity.

A particularly unpopular
move was his attempt to
quash the itinerant lay
preachers known as 'lecturers',
who were numerous in both
Norfolk and Suffolk. Many
of these had received no
formal clerical training and
preached doctrinally suspect

Nonconformist views which were felt seriously to undermine the authority of the established Church. It was inevitable Wren would become a target for Puritan reprisal.

In 1641 Wren was committed to the Tower of London. Released briefly in 1642, he was sent back, and remained there for eighteen years. After the Restoration, he led the movement to rebuild St Paul's Cathedral, with his nephew Christopher as architect. Christopher Wren also rebuilt Pembroke Chapel, Cambridge, which his uncle had promised he would endow as a thanksgiving gift to his old college upon his release from prison.

Wren was buried at Pembroke. Upon the coffin in his magnificent funeral procession were a silver mitre and crozier, traditional ornaments for a bishop and a fitting tribute. Having spent so much of his life imprisoned for his beliefs, Wren was commemorated finally as he had wished: with full Episcopal honours.

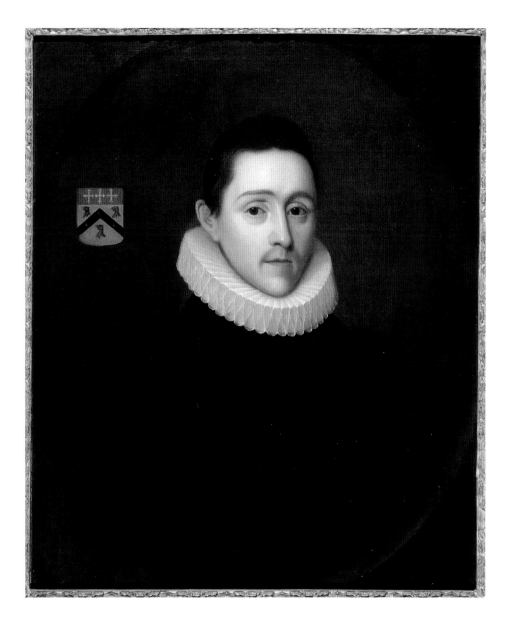

Within the image:
The house above the
Clock Standeth
The upper gallery
The neither Gallery
The seate for ye Maiors halfe his Bretheren
The Bishops
Chancellors
Seate
The Maiors Officers seate
The Singing mens Seates
The Portraiture of the South side of ye Quire in the Cathedrall Church
The North side is of the same forme The Pulpit Standing opposite unto the Bishops Seate

4.3 EAST VIEW OF NORWICH CATHEDRAL CHOIR

Artist unknown

1630s

Ink and crayon on paper

29.6 x 44.1 cm

Norwich Castle Museum & Art Gallery

During the 1630s and 1640s, Norwich Cathedral became a stage upon which the bitter opposition, religious and political, between Puritans and Laudians was played out. This anonymous sketch illustrates a place of particular significance during this turbulent period.

Under Wren's episcopacy, the city's officials, many of them Puritan, were compelled to attend cathedral services every Sunday to demonstrate their obedience to the established church. Most were seated in the area depicted here, where they were subjected to numerous indignities inflicted by those seated in the gallery above, motivated either by anti-Puritan feeling or sheer desire to revile the civic authorities. An account from 1636 details people spitting, throwing things, and even urinating

and defecating on the aldermen's heads.

The desecration of the cathedral's interior fabric in 1643 is described earlier in this chapter. But even the seating layout was a political issue. After it had been stripped of its ornamentation, the cathedral was rearranged. The mayor was seated where the high altar had been, and the aldermen in the space formerly occupied by the sanctuary. This was a deliberate move to obliterate the Laudian focus on sacraments and the consecrated priesthood.

It is interesting to contemplate the motives of the artist in producing this work at this significant time. The precise descriptions of seating, scrawled all over the drawing, date from before the Civil War rearrangement, and also suggest his primary aim was less artistic than informative. It is an intriguing sketch: possibly produced by someone associated with Bishop Wren, to illustrate the cathedral layout when he was planning to reform his unruly diocese.

4.4 RELIGIO MEDICI

Thomas Browne (1605–82)
Printed book, (Franciscus Hackius)
1644
13.3 x 7.5 cm
By kind permission of the Syndics of Cambridge University Library, Keynes, C.2.12

The physician and philosopher Sir Thomas Browne lived in Norwich from 1637. *Religio Medici* ('The Religion of a Doctor') is his first and probably most important work. It is the first known example of an individual thoughtfully combining his sincere and devout religious beliefs with the educated rationality of his scientific training.

The work was first composed for private circulation around 1635, a time of great religious unrest in English society. Indeed, *Religio Medici* may form Browne's response to the discord surrounding him, steering a personal way through the maze of theological complexities of his time to forge an individual philosophy which made sense of both religion and science. It was officially published in 1643 and further editions followed throughout his lifetime, bringing Browne great popularity. It has proved influential amongst thinkers ever since.

The frontispiece shown here depicts a man falling from a mountain, caught by an arm appearing from the heavens.

The caption reads *'a caelo, salus'* ('from heaven, salvation'), underlining the need to trust in God in the face of earthly calamity, another reflection, perhaps, on contemporary society.

Browne wrote as though for a private diary, with an engaging candour. His honesty and lack of dogmatism led to an open-mindedness almost unknown during the early modern period. It is equally unusual to hear such an unmistakably personal voice coming through the rhetorical strictures customary for the time. As such *Religio Medici* is a unique document and its lack of orthodoxy meant that it was placed on the papal list of banned books by 1645.

4.5 THE DISCOVERY OF WITCHES

Matthew Hopkins (d. c. 1647); Printed book, (for R Royston at the Angell in Ivie Lane), 1647; 18 x 13 cm
British Library E.388. (2)

This woodcut forms the frontispiece to *The Discovery of Witches*, a short book published by self-styled Witchfinder General, Matthew Hopkins (c. 1620–47). It is a unique source of information about his witch-finding career, expressed in his own words. The book was first published in Norwich, as Hopkins's defence of his beliefs. By 1647, informed public opinion was beginning seriously to doubt his sincerity. A clergyman, John Gaule, had even published a book in which he accused Hopkins of working more for his own gain than for the glory of God.

The woodcut depicts Hopkins with two of his first victims, Elizabeth Clarke and Ann West from Manningtree, calling on their supposed familiars or 'imps'. Imps were demons in the guise of ordinary animals. Witches were purported to suckle these imps with their blood to seal a pact with Satan, then use them to work evil magic. Suspected witches were searched for marks on their bodies at which the imps might feed. The suspects were deprived of sleep and watched for several days in the belief the imps would appear. Elizabeth Clarke, an octogenarian, one-legged widow, was imprisoned in her house and eventually two dogs, a rabbit, a cat, a toad and a ferret came to her call. Their unusual names ('Pyewackett', 'Jarmara', 'Holt') sealed her fate as it was thought that only Satan could have chosen such names.

This naively rendered image is a poignant record of a tragic period in East Anglian history when misguided religious fervour led to imprisonment and death for so many people. Some witches today name their pets after Elizabeth's animals, to honour her memory.

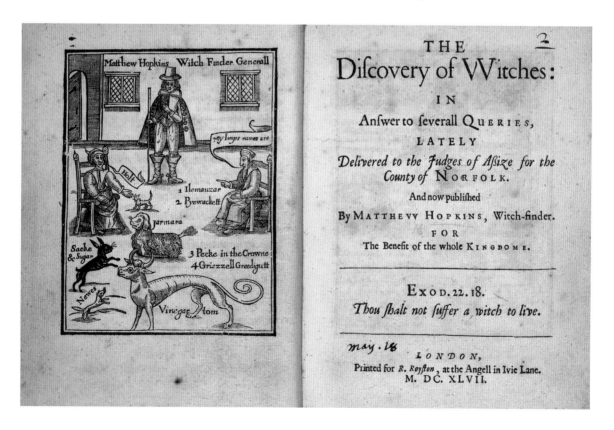

4.6 SIGN BEARING COAT OF ARMS OF THE COMMONWEALTH AND THE ROYAL ARMS OF KING CHARLES II

c. 1640–60

Artist(s) unknown

Polychromed wood; 145 x 132 cm approx.

Church of St Nicholas, North Walsham, Norfolk

From the Reformation onwards the presence of royal coats-of-arms in churches became increasingly common, symbolising the monarch's authority as head of the church in England and making explicit links between the congregation's duty of loyalty to God and to the Crown.

There are many excellent surviving examples of royal arms in Norfolk churches. Quite commonly these are palimpsests, showing signs of alteration and over-painting as monarchs changed. However, this coat-of-arms from North Walsham is not only highly unusual in being double-sided but, uniquely, features a Commonwealth coat-of-arms on the reverse side to the arms of Charles II.

The Commonwealth arms were designed deliberately to remove all associations with royalty but to retain symbols of the nations of England, Scotland and Ireland. The aim was to express national identity together with a desire to represent the country as unified under one rule within the Commonwealth. This panel portrays a simple version of the arms: the St Andrew cross symbolising Scotland does not appear with the St George cross and the harp of Ireland. This could suggest a date of manufacture early in the Commonwealth period.

Archival evidence indicates that there was once an earlier set of royal arms, those of Charles I, made for St Nicholas' church, although they have not survived. The Commonwealth arms, on this panel, appear to have been painted over a text, of which traces are still visible. This suggests that, in the process of making, economy and speed were more important than a high degree of finish. It may be for this reason that the arms of Charles II were simply added onto the blank side of the panel in 1660, without the painter seeing the need to obliterate the redundant Commonwealth flag. This unique survival affords a glimpse into what must have been a common sight in churches during the civil war, signalling clearly the indissoluble associations between church and state.

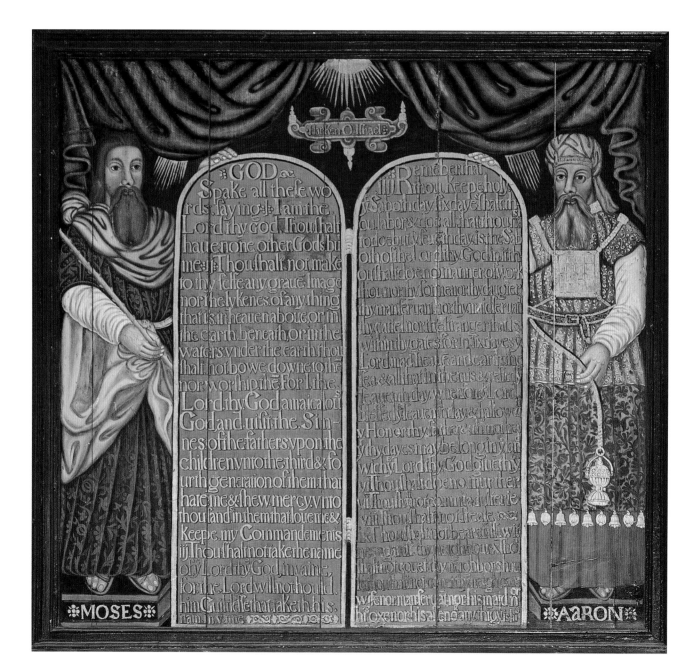

Portrayals of Moses and Aaron, accompanying the texts of the Ten Commandments, the Creed and the Our Father appear frequently in churches in the century following the Reformation. These boards formed part of a complex debate that took place during the seventeenth and eighteenth centuries concerning the appropriate use of imagery in churches. Portraits of religious figures could suggest the idolatrous 'popish' practices which were such anathema to Protestants of all persuasions. Saints, especially in three-dimensional form, were therefore completely avoided. Moses and Aaron however, being Old Testament figures and almost always rendered as flat images, were considered far more acceptable.

To explain this seeming paradox, several arguments have been advanced about the symbolism and associations which made Moses and Aaron acceptable. Moses, as the original receiver of the Ten Commandments, could be seen as the unique channel whereby God made His Word known to mankind. Aaron was traditionally seen as the archetypal priest in the Old Testament and therefore as prefiguring the Christian Church.

This board is a fine example of this type of artefact. In typical pose, Moses and Aaron hold their tablets prominently, presenting them to the congregation. They stand at either side as if to form a frame for the sacred texts. Together with the accompanying Creed and Lord's Prayer boards they epitomise the most important elements in English Protestant worship during the seventeenth century, combining approved visual imagery with an emphasis on supremacy of the Word of God.

4.8 HEX-BOTTLE
Seventeenth century
Stoneware bottle containing
linen heart stuck with iron pins
Bottle 21.2 x 11 cm,
cloth heart 5.5 x 4.5 cm
*Norwich Castle Museum
& Art Gallery*

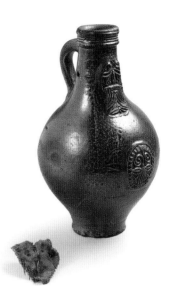

Folk magic is an enduring tradition in East Anglia and includes making charms for protection against evil spirits or malevolent witchcraft. These stoneware bottles, known as 'bellarmines', are one of the most common objects used for this purpose, especially during the seventeenth century. They usually appear buried under the fireplace, or in the porch, and are found particularly frequently in Norfolk.

The term 'bellarmine' may have many origins. One possibility is that the bearded face and rotund belly caricatured a Catholic cardinal of this name in Germany where these bottles originated. It seems that their special suitability for magic lay in their resemblance to the human figure.

This bottle was buried under the threshold of the Plough Inn in King's Lynn. It may originally also have contained urine or human hair as well as pins and the linen heart. The bottles were used as 'spirit traps' – placed at what were considered the most vulnerable points in a house where evil might enter. The presence of hair or urine may have been intended to make the spirit or witch believe that the person they wished to harm was in the bottle. They would then enter the bottle and be stabbed by the pins. Iron was thought to have strong protective qualities. In this case, the heart may have indicated a desire to inflict a mortal wound.

These folk objects evince powerful beliefs. As almost everyone believed in witches, equally most people believed in the power of wise women or cunning men to counteract evil spells with 'white' magic, such as the making of hex-bottles.

4.9 THE OLD MEETING HOUSE
J. Gleadah after James Sillett (1764–1840)
c. 1830
Lithograph on paper
16.8 x 23.2 cm
Norwich Castle Museum & Art Gallery

The Old Meeting House, so-called to distinguish it from the Octagon Chapel built in the early eighteenth century (see 5.5), is one of the oldest surviving Nonconformist places of worship in England. It was completed in 1693, soon after the Act of Toleration of 1689. Its earliest congregations were descended from those who had returned to Norwich after going into exile during the 1630s to escape Matthew Wren's Laudian reforms, although French and Flemish Protestant immigrants also worshipped here.

The external architecture of the elegant building reflects Nonconformist customs of the time. There are two doorways, allowing men and women to enter separately. The interior, in which all the pews face towards a central, raised pulpit, is entirely geared towards a form of worship which focused upon preaching, in opposition to the arrangement of pews facing a high altar as advocated by Matthew Wren. When the Meeting House was built, this design must have represented for the congregation a radical and welcome move towards religious freedom. Another important feature of the interior which still survives is a mayoral sword and mace stand, a tacit testament to the fact that by this date Nonconformists were permitted to partake in civic life.

4.10 THE WHEEL OF THE YEAR
2007
Wood, textile, metal, plastic, plant fibres
Diameter 60 cm approx.
A Norfolk Pagan coven

As a contemporary craft object made for ritual use, this is a natural successor to the artefacts of magic and belief made in earlier centuries. Many, though not all, contemporary Pagans celebrate eight festivals, or sabbats, within a year visualised as a circle. This system is sometimes known as the 'Wheel of the Year'. The festivals are Samhain/ Halloween at which the Pagan year begins, Yule/ Winter Solstice, Imbolc, Ostara/Spring Equinox, Beltane, Summer Solstice, Lammas/Lughnasadh and the Autumn Equinox. Here, the cycle has been visualised as a literal wheel by members of a Norfolk coven, who made the object from wood found locally. During the ritual celebrated at each festival an appropriate symbol provided by each coven member in turn was hung upon it.

There is great emphasis on a highly individual

4.11 BISHOP WREN'S FUNEREAL MITRE AND
CROZIER, c. 1667
Maker unknown
Silver and silver-gilt
Mitre height 30.5 cm; crozier 177 x 10 cm
*By kind permission of the Master and Fellows of
Pembroke College, Cambridge*

4.12 HATCHMENT OF SIR THOMAS
SAVAGE, 1635
Long Melford, Suffolk
Oil on canvas; 108 x 108 cm
Church of the Holy Trinity, Long Melford

4.13 ANTI-WITCHCRAFT AMULET, 1654
Norfolk
Ink on paper; 14.8 x 20.8 cm
Facsimile
Norfolk Record Office

4.14 MUMMIFIED CAT,
Fifteenth century or later
Thetford, Norfolk
Organic remains; 32 x 45 x 70 cm
Gressenhall Rural Life Museum, Norfolk

4.15 CARVING, GIVEN TO MYLES
CUNSTANCE OF CORPUSTY BY OLD
MOTHER FYSON, c. nineteenth century
Maker unknown
Painted wood and glass; 36 x 25 x 9.3 cm
Strangers' Hall, Norwich

approach to faith and practice within modern Paganism, reflected in the variety
of objects hung on the wheel. These range from a commercially-made key-ring
depicting the Green Man to a hand-forged miniature sickle made by a coven
member who is a farmer and blacksmith. Everyone with a creative streak will
make their own objects wherever possible, both as a meditation and as a
personal offering of time and creative effort to their Gods. For this local coven
the wheel serves as a visual reminder of the eight festivals and the passing of
the seasons. The objects, although simple, for their makers and for the rest of the
coven symbolise the deities acknowledged, and the activities appropriate to
each festival.

At the end of the cycle the wheel would normally be burned and a new
one made. This one has been saved, providing a rare glimpse into the practices
of one Norfolk coven.

5

COLLECTORS AND PHILANTHROPISTS; DISSENTERS AND REVIVALISTS

Andrew Moore

From the beginning of the eighteenth century, in Norfolk, as elsewhere, debates concerning religion took a far less violent form than in previous centuries. Nevertheless, Christian religious beliefs were expressed in increasingly diverse ways. The connections between art and religion, although still strong, were gradually changing.

A number of great religious art works were assembled during this period. Some of the most prestigious collections in Britain were created in Norfolk in the early eighteenth century within the context of a Palladian-style building programme. Altarpieces from the European mainland were proudly displayed for their aesthetic splendour and value as rarities, with little apparent acknowledgement of their religious origins. England's first Prime Minister, Sir Robert Walpole, acquired Roman Catholic treasures for his Norfolk seat at Houghton, whilst ruthlessly quashing Jacobite dissent in Scotland. Thomas Coke, later First Earl of Leicester, filled his Baroque-inspired Hall at Holkham with works of art which were often Roman Catholic in origin, including major altarpieces gathered from monasteries and churches during his travels (5.1).

In the early eighteenth century the Norfolk Whigs in power were Protestant. Within the county, the influence of leading Catholic families, notably the Howards and the Bedingfelds, had waned, although they continued to practise their faith discreetly. During the last quarter of the century their legal status gradually improved, culminating in the Emancipation Act of 1829, which finally allowed Catholics to participate fully in public life. In the late nineteenth century the Jerningham family, who had provided refuge for Catholic Recusants at Costessey, became principal supporters when Henry Fitzalan Howard, the fifteenth Duke of Norfolk, established the second great Cathedral of Norwich, designed by George Gilbert Scott (5.10).

Both Norfolk and Suffolk continued to house Christian groupings questioning the official religion of state, Anglicanism. The best-known name amongst Norfolk Nonconformists is the Quaker Elizabeth Fry, a tireless reformer of prisons (5.4), and also her brother, the abolitionist and reformer Joseph John Gurney. Abiding monuments of this period were buildings such as the Octagon Chapel in Norwich (5.5), acclaimed by the

Methodist John Wesley as 'the most elegant [meeting-house] in Europe'.[i]

Prominent among the Norfolk artists was John Sell Cotman, who suffered a number of setbacks in his career. Yet he seems to have found some solace and purpose in clubbable nonconformity. In spiritual matters he was also advised later in life by the devout Mary Turner, wife of his main patron Dawson Turner. Like the well-known local painter John Crome, Cotman became a member of the Masonic Grand Lodge in Norwich. He also joined the United Friars Society, founded in Norwich in 1785 as 'a society for the promotion of intellectual culture and social fellowship' (5.3). This was a very different grouping when compared with the Norwich Society of Artists founded in 1803, although they did number artists among their membership. The seventh article of membership for the Norwich Society of Artists, revised in 1818, stated 'all political and theological discussions are not to be admitted'. Perhaps religious debate had been one of the factors behind the splitting of the society in 1816. Thus, whilst religious art no longer sparked violence, it still had the power to be divisive.

A feature of nineteenth-century Norfolk was the nature of its participation in the Industrial Revolution. The local economy retained an essentially rural foundation in the face of industrial change. Railways and urban industrialisation were slow to have any marked impact on the landscape. Low-lying pastures continued to be dominated by medieval churches and wayside crosses marked the historically religious nature of many land boundaries. The wide, flat horizons of the region exerted a hold over artists who chose to link the immanence of God with a Romantic and picturesque idea of nature (5.6). Moreover, the example of landscapes from seventeenth-century Holland fuelled similar responses in the artists of nineteenth-century East Anglia, in ways which seem to extend beyond the simply art-historical influences of style and technique.

Jeremiah James Colman, the Victorian collector of the Norwich School of Artists, personified the philanthropic businessman of the era. He combined an interest in art with strong religious beliefs, and founded a business empire based on mustard seed whilst also supporting Norwich's new museum on Castle Hill. Part of his wealth, generated by working the land, was spent on patronising Norfolk artists, but he also had a philanthropic desire to improve the lot of his workers and the city's cultural inheritance. His collection included the work of Norwich artist Frederick Sandys (1829–1904), whose subject matter could be both Christian and mythological (5.8). The sentiments of philanthropy were to extend to his son Russell James Colman, who bequeathed the family collection of paintings to the City of Norwich in 1947.

Such patterns of nonconformist thinking, which had led to Norwich being dubbed the 'Jacobin City', set the scene for the increasingly secular twentieth century (5.9, 5.11). The families which became influential within Norfolk during this period, such as the Gurneys and the Colmans, joined the more ancient landed families such as the Bacons, Bedingfelds and Howards, even as social change diminished the traditional congregations of believers. One early manifestation of the religious diversity of the present day can be seen in a gradual return of a Jewish community to East Anglia. After Cromwell's readmission of the Jews in 1655, by the end of the eighteenth century a small group was living in Norwich, and by the early nineteenth century there were also sufficient numbers in Yarmouth to warrant a synagogue (5.2).

Norfolk today also includes a Sikh community which, although numerically small, is culturally significant. The Maharajah Duleep Singh (5.7) lived and is buried at Elveden, outside Thetford, ensuring that this area is a place of continuing importance for Sikhs. Meanwhile, his youngest son, Prince Frederick, who was educated at Eton and Cambridge, became a leading authority on the families of Norfolk and Suffolk. Through the twentieth century the scene was set for a world of modern pluralism and contemporary individualism, combining the influence of the traditional belief systems of the locality with a new multicultural awareness.

5.1 THE RETURN
FROM EGYPT
Peter Paul Rubens
(1577–1640)
1618–19
Oil on canvas
287 x 208 cm
*Viscount Coke and
the Trustees of the
Holkham Estate*

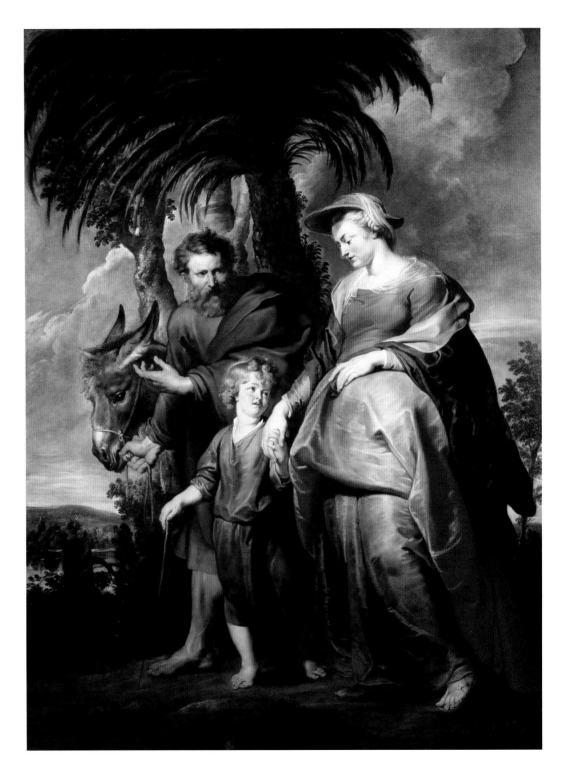

The Return from Egypt is the finest single altarpiece to remain in Norfolk today. It represents the taste of the young Thomas Coke established when on his European Tour in the period 1712–18. Coke's grand tour inspired him both as a collector and as the builder of Holkham Hall in the manner of a Roman Baroque palace. He was, however, not a Roman Catholic. Rather, he probably bought the painting (in 1745) because of its quality and the renowned maker. This work therefore encapsulates an important point: for eighteenth-century collectors, artistic appreciation was more important than religious subject matter. Moreover, Matthew Brettingham described the composition as 'painted with admirable force, and Brilliancy of Colouring. There is one at Blenheim...'.[ii] This identifies another reason why Thomas Coke bought this piece. There was a lesser version, purchased for Blenheim Palace in 1708 (today at Hartford, Connecticut).

The Return from Egypt was originally commissioned for the Jesuit church in Antwerp where it formed part of a large painted cycle by Rubens and his studio, completed in 1622. The subject matter is unusual and, in Rubens's hands, it became a powerful meditation on the relationship between Jesus, Joseph and Mary, the three members of the Holy Family. This, in turn, fits closely with the original purpose of the painting. In post-Reformatory Roman Catholicism, there was a new emphasis on the Holy Family as a model for human familial relations. But it was also meant to be an impressive work of art, made to showcase the indubitable creative powers at the command of the newly resurgent Roman Catholic Church in the Low Countries in the early seventeenth century.

5.2 SET OF RIMONNIM FOR TORAH SCROLL

Eighteenth–nineteenth century
London or Europe, with London hallmarks (on mount)
Silver filigree
Each 35 x 12 cm
The Trustees of the Norwich Hebrew Congregation

The Torah Scroll (5.18) for which these *rimonnim* are the finials was smuggled out of Czechoslovakia during the Second World War by a gentile and taken by boat to Great Yarmouth, where a Jewish community had existed for many years. The synagogue of the town, established in 1847 and apparently the smallest in Britain, had ceased to exist by this time so worship took place in private homes. Although somewhat depleted, the community was substantially bolstered by refugees from occupied Europe. The scroll therefore survives as a memento of its original, vanished community and also of the Great Yarmouth congregation. It is an heirloom for the present congregation in Norwich.

The *rimonnim* (meaning 'pomegranates'; illustrated above) are the Torah 'crowns' that cover the poles of the Torah Scroll as it is processed through the congregation. Bells focus each worshipper's attention on its progress and are often echoed by bells on the hem of the robe of the officiant. The craftsmanship of these objects represents the congregation's love for and commitment to the Torah. These rimonnim were used in the synagogue at Great Yarmouth. When it closed in the late nineteenth century, they came to the Norwich Synagogue.

The Norwich Synagogue, built in 1848, was destroyed by bombing during the Second World War but the carving on the original columns has been reused to decorate the gate-posts of the current synagogue in Earlham Road. Norwich is the only town in Britain to have a street named Synagogue Street, a testament to the enduring importance of the Jewish community.

John Sell Cotman (1782–1842)
c. 1801
Oil on panel; 94.9 x 74 cm
*Norwich Castle Museum & Art
Gallery*

John Sell Cotman's national
reputation as the leading artist
and teacher of the Norwich
School was rivalled only by
that of John Crome. Cotman's
paintings of religious subjects
were principally of churches, in
Norfolk and Normandy, and
also of monumental brasses
in Suffolk, commissioned by
his patron Dawson Turner of
Great Yarmouth for antiquarian

c. 1815
Samuel Drummond
(1765–1844)
Watercolour on ivory
11.4 x 8.3 cm
*Lent by the National Portrait
Gallery, London*

Elizabeth Fry (née Gurney,
1780–1845) was born into
a well-to-do Quaker family
in Norwich. In 1798, much
impressed by the preaching
of a visiting American plain
Quaker, William Savery,
Fry became one of the Plain
Friends whose religious
observance was very strict.
She became renowned for
her Christian compassion
which led her to work with
prisoners, the institutionalised
and the homeless.[v]

Drummond's portrait
demonstrates the strict rules
regarding plainness of
dress that characterise the
Quaker way of life (Quakers
were so-called as they
'quaked in the fear of God'),
while the barred window
and Bible evoke Fry's prison
work. She became greatly
concerned about
the condition of women
prisoners in Newgate in
London, where the accused,

purposes. Much of Cotman's work suggests an Anglican whose art was only tangentially
related to his faith. However, his choice of St James of Compostela as a subject was an act
of overt Christian faith harnessed to the social mores and beliefs of the United Friars Society,
founded in Norwich in 1785 as 'a society for the promotion of intellectual culture and social
fellowship'.[iii] Each member assumed the habit of a monastic order; other artist members, apart
from Cotman himself, who was elected unanimously on 27 January 1801, included William
Beechey (a founder member), Edward Miles and Humphry Repton. From 1793 until 1828
the society carried out charitable works, including running soup kitchens. Cotman resigned
from the United Friars on 1 March 1808.[iv]

In terms of style, Cotman's image draws on the Gothic Revivalism of the early nineteenth
century whilst the saint standing beside a tomb seems to refer to the original vision of St James,
the bright light showing the site of his final rest. The fourteen Cardinal Virtues are listed on the
sheet held by the saint and he points specifically to Charity. Cotman gave the painting to the
society as a 'donaria' on entering the brotherhood. The painting, one of Cotman's earliest
in oils, hung behind the abbot's chair in the Conclave Room, one of the society's two rooms
in Crown Court off Elm Hill, Norwich. Cotman returned to ecclesiastical subjects later in his
career when he painted two studies of monks especially for exhibition in Bath in 1836, but
he only regarded them as 'pot boilers'.

both innocent and guilty, were crowded together in appalling conditions. While her reputation is indicated by the words of a visiting American minister in 1818, 'the wretched outcasts have been tamed and subdued by the Christian eloquence of Mrs Fry',[vi] it was her introduction of a prison matron, supplies of clothing and a school that made a real difference.

In Norwich the Religious Society of Friends had undergone persecution during the late 1600s, their meetings often taking place either in open spaces, notably on Mousehold Heath, or in the Norwich Gaol, where many of the congregation were incarcerated. A close-knit community, they acquired in 1670 an acre of land in Gildencroft as a burial ground, while the Friends Meeting House opened in Goat Lane in 1679. This was subsequently rebuilt in a gracefully understated fashion in 1826.

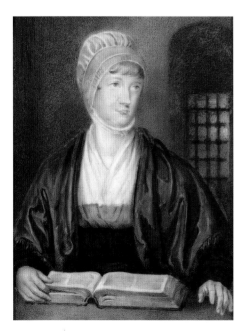

5.5 THE OCTAGON CHAPEL, NORWICH

Undated, published 1828; James Sillett (c. 1764–1840)
Pencil and grey wash; 13.5 x 21.6 cm
Norwich Castle Museum & Art Gallery

The Octagon Chapel was built adjacent to the Old Meeting House in Colegate in Norwich at the expense of the congregation in 1756. The designer was Thomas Ivory (1709–79), whose octagonal structure helps to focus the attention of the congregation on the pulpit and the Holy Table. When John Wesley visited the following year he wrote: 'I was shown Dr Taylor's new meetinghouse, perhaps the most elegant one in all Europe.' The Octagon subsequently became the model for a number of Methodist chapels.[vii]

The original Presbyterian congregation took up Unitarianism, and the building has continued to attract Unitarian followers. The twentieth-century historian and lord mayor of Norwich, R.H. Mottram, was a descendant of the original trustee of 1686, John Mottram. The writer and linguist William Taylor worshipped there in the 1830s, as did the leading Unitarian thinker James Martineau, brother of Harriet Martineau. The botanist Sir James Edward Smith and the anti-slavery activist William Smith (MP for Norwich 1802–30) also worshipped there and it was Smith who successfully campaigned for the repeal of the last remaining acts that penalised dissenters.

This image, *The Octagon Chapel, Norwich*, was published by James Sillett in his *Views of the Churches, Chapels and Other Public Edifices of the City of Norwich* in 1828. Sillett was remarkable for his painterly skills whereby he excelled equally at still life, at portraiture and in the depiction of buildings. His publication of 1828 boasts buildings in modern style and was probably seen as a complement to Robert Ladbrooke's *Views of the Churches of Norfolk*.

5.6 VIEW OF CROMER
c. 1835; James Stark (1794-1859)
Oil on deal panel; 60.8 x 85.8 cm
Norwich Castle Museum & Art Gallery

The work of James Stark here stands for the many local painters of Norfolk, whose varied images of the county cultivated a national reputation for the Norwich School. Stark's real engagement with the promotion of local interests can be seen in his address to the Norwich Society of Artists in 1827 entitled 'Of the Moral and Political Influence of the Fine Arts': 'we may yet see Norwich holding a fair place among other cities of the kingdom in fostering the arts of peace so eminently qualified as they are acknowledged to be, to lead to the attainment of the highest purposes of social intercourse'. Also, he added: 'It has been a favourite position of mine, Mr President, that [a] man influenced by proper feelings for art, must be a religious man'.[viii] This suggests an attitude to the painting of landscape similar to that which motivated the Dutch Masters, who portrayed creation to glorify the Creator. In the work of Stark's contemporaries, there is perhaps a similar appreciation of the divine in nature.

The Church of St Peter and St Paul with its commanding west tower dominates the town of Cromer and the surrounding landscape. It has always acted as a beacon to those at sea as much as to those on land. The prevalence of medieval and later churches in the Norfolk landscape – silhouetted against the looming skies of the low-lying landscape and combined with wayside crosses marking local land boundaries – would prevail upon artists at this time and, arguably, ever since. During the second half of the nineteenth century the artistic representation of a place was regarded as both worthy and morally improving in itself. This implied that the act of looking, and of painting, had almost religious qualities.

5.7 PORTRAIT OF MAHARAJAH DULEEP SINGH

1854

Franz Xavier Winterhalter (1805–73)

Watercolour; 28.8 x 18.7 cm

Signed and dated *F Winterhalter/*

15 July 1854

The Royal Collection

Duleep Singh (1838–93) was confirmed as Maharajah to succeed the powerful Sikh ruler Ranjit Singh, who died in the Punjab in 1839. With the child's mother as Regent, he was made a ward of the British Government. This was a period of colonial expansion for Britain and in 1848 a Sikh rebellion presented an opportunity to send troops into the Punjab, ostensibly in the name of the young Maharajah, to annex the territory. In 1849 the Maharajah resigned his sovereign rights and property (including the Koh-i-Noor diamond) to the British Crown.

With a pension and money from the British Government he purchased the Elveden Estate in 1863, a few miles south of Thetford. He lived the life of a country gentleman and between 1863 and 1870, with the help of the architect John Norton, enlarged Elveden Hall into an Oriental extravaganza unparalleled in England. The walls, pillars and arches of the central domed hall were covered with intricate Indian ornamentation, all in white Carrara marble, the doors with panels of beaten copper. However, by the 1880s the Maharajah was finding his dependence on the Government intolerable and he determined to return to India. He was not allowed back into his native land, however, and so settled in Paris, where he died in 1893.

The story of the exile of the fifteen-year-old Maharajah from the Punjab is a poignant testimony to the Victorian annexation of Sikh heritage. Today Maharajah Duleep Singh is regarded as an inspiration by Sikhs who respect his journey from being a favourite of Queen Victoria to his more ambivalent relationship with Britain once he had planned to renounce Christianity and return to the Punjab.

This study is related to the most dazzling of the portraits of the Maharajah commissioned by Queen Victoria. Winterhalter was highly fashionable as court painter to European royalty, first visiting England in 1842. He returned several times to paint Queen Victoria, Prince Albert and the English Royal family.[ix] The Maharajah's son, Prince Frederick became an even greater supporter of the British way of life, creating a collection of portraits which he presented to the town of Thetford.

5.8 MARY MAGDALENE (TEARS, IDLE TEARS)
1862
Frederick Sandys
(1829–1904)
Oil on canvas
29.2 x 24.8 cm
Norwich Castle Museum & Art Gallery

5.9 PORTRAIT OF WILLIAM BOOTH
1902
Olive Edis (1876–1955)
Platinotype; 24.3 x 19.1 cm
Lent by the National Portrait Gallery, London

The Magdalene is recognisable by her antique alabaster vial of oil of myrrh which she holds close to her breast (Luke 7:37–38). The portrait is sensuous, her luxuriant hair inspired by the model and the example of Sandys' friend, Dante Gabriel Rossetti. This was the second time Sandys had portrayed the Magdalene, the first (in 1859) being in a less overtly seductive manner. Here the artist dresses his subject in a suitably oriental and flamboyant robe decorated with butterflies, while the tear on her cheek evokes the Magdalene's penitence. Critical reaction to the painting was mixed, reflecting unease with this voluptuous subject being proffered as Mary Magdalene. The model was sixteen- or seventeen-year-old actress Mary Emma Jones, who sat for Sandys on a number of occasions and later became his common-law wife and mother of his ten surviving children.[x]

This painting was owned by the Norwich textile manufacturer and philanthropist William H. Clabburn, who also owned Rossetti's *Mary Magdalen at the door of Simon*, painted the following year. Such subjects were of interest to patrons at this period as much for their visual characteristics as for their religiosity. Clabburn and Sandys were friends as well as patron and artist, and Clabburn would lend the artist money when his finances were difficult. In the context of Clabburn's collection, *Mary Magdalene (Tears, Idle Tears)* represented a moral centre for both Victorian patriarch and artist, neither of whom saw a problem in combining religious and sensuous subject matter.

William Booth (1829–1912) was originally a Methodist preacher before founding the Salvation Army. He served as its first General, or leader from 1878 until his death. The origins of Booth's conviction lay in his conversion at the age of fifteen to Methodism, shortly after the death of his father. He began to preach in his home town of Nottingham but after moving to London took up evangelical teaching in public spaces, styling himself on the revivalist American preacher James Caughey. Booth then gave up Methodism in order to concentrate upon evangelism. His wife joined him in his ministry and together they established the Christian Revival Society in the East End of London, later renamed

the Christian Mission, then the Salvation Army. Booth became honoured across the world for his message of salvation through charitable work. Following a visit by Booth, the Norwich Corps number 304 was formed in December 1882 and established at a permanent site in St Giles, Norwich, ten years later.

This photograph of Booth, taken by Norfolk portrait photographer Olive Edis (Mrs Galsworthy) and her sister Katherine Legat (née Edis), records a visit to Norwich by Booth in 1902. The sisters, daughters of architect Sir Robert Edis, began their work in the early 1900s at their Sheringham studio. They photographed a diversity of sitters from local fishermen to nobility. Olive Edis later became a war photographer for the Imperial War Museum. She is also notable for her use of Sepia Platinotypes and, from 1912, for innovative use of colour autochrome portraits. Booth's visit to Norwich was part of his scheme to spread the message of the Salvation Army; an aim continued by the Norwich Citadel to this day.[xi]

5.10 STUDY FOR THE ROMAN CATHOLIC CATHEDRAL OF ST JOHN THE BAPTIST
1903
John Oldrid Scott
(1841–1913)
Pen and ink and coloured chalks on tracing paper
112 x 94.5 cm
Norfolk Record Office RC 1/57 (Archives of the Roman Catholic Diocese of East Anglia)

The cathedral of St John the Baptist, built for Henry Fitzalan Howard, fifteenth Duke of Norfolk, was begun in 1884 and completed in 1910. It was designed originally by George Gilbert Scott II and actually completed to the designs of John Oldrid Scott, the architect's brother, following the former's death in 1897. Less well known than his brother, John Oldrid Scott had entered his father's office as a pupil in 1860, before inheriting the practice in 1878. The nave was designed first, principally by George Gilbert Scott, but this is one of a number of surviving architects' designs that show just how the brothers' styles were so similar that they are hard to differentiate. This particular study, dated 13 October 1903 (top right) demonstrates the continuing involvement of the Duke of Norfolk himself in the overall design; the inscription, top left, reads: 'The Duke is to be consulted as to angels in relief in spandrels'. The Duke was instrumental in choosing the historicist Early English Gothic style, which is not prevalent in Norfolk. The group of designs to which this belongs were used by the stone masons on site, the blue crayon describing stone, the pink crayon indicating marble.

The church became the Roman Catholic Cathedral in 1976 for the newly created Diocese of East Anglia, the seat of the Bishop of East Anglia. The church design fully justifies the High Victorian benefaction and optimism of the original gift. The architect's son, Sir Giles Gilbert Scott (1880–1960) was also to work on a Roman Catholic commission in Norfolk. He designed the church of St Joseph at Sheringham in response to a donation in 1901 by Elizabeth Deterding.[xii]

5.11 UNITED REFORMED CHURCH CROSS

2010; Norman Manners (b. 1931, Castleford, Yorkshire)
Painted MDF board, mounted on polycarbonate; 107 x 61 cm
Princes Street United Reformed Church, Norwich

The United Reformed Church of Great Britain was formed as a Christian church by the union of the Presbyterian Church of England and the Congregational Church of England and Wales in 1972. In 1981 it united with the Reformed Association of Churches of Christ and in 2000 with the Congregational Union of Scotland. The theological roots of the URC are founded in Calvinism. The Reformed tradition today is one of the largest single strands of Protestantism with more than seventy million members world-wide.

This distinctive cross is one of several made for the United Reformed Church in Princes Street, Norwich. The crosses are regularly rotated, providing a changing focal-point for the church. They can be deliberately 'theatrical' in conception, made using simple materials such as MDF, theatrical gel and acetate with painted decoration. Placed at a high vantage point, typically hung by a cord from a simple nail, each one achieves an individual dramatic effect.

To express the Reformed ethos of purity and simplicity, the cross has been combined with a fish, used as a symbol for the URC since 1972. The fish was first used as a secret sign of Christianity in the early Christian communities of Alexandria, under Roman persecution. Taken from *icthus*, the Greek for fish, the word ΙΧΘΥΣ has represented Christ ever since.

The current Norwich Church, built in 1869, was designed by Edward Boardman, himself a Congregationalist. Next to the church is Boardman House, built ten years later, for use as a Sunday School. The Congregation continues its work in community fellowship through these buildings, in concert with social services and other voluntary organisations such as Age Concern. The United Reformed Church in Norwich receives regular visits from an African children's choir, while the local Zimbabwean 'Forward in Faith' group also meets there regularly. The church thus represents one strand of the continuing traditions of Nonconformity in Norwich. *EAM*

5.12 THE MYSTIC MARRIAGE OF ST CATHERINE, 1660s

Carlo Maratta (1625-1713)
Oil on copper; 37 x 37 cm
Private Collection

5.13 THE HOLY FAMILY, WITH ST CATHERINE

Carlo Maratta
Oil on copper; 36.9 x 36.9 cm
Private Collection

5.14 TORAH SCROLL, c. seventeenth century

Central Europe (now Czech Republic)
Parchment with wood; 110 x 30 cm
The Trustees of the Norwich Hebrew Congregation

5.15 BIBLE, CHRISTENING PRESENT TO MAHARAJAH DULEEP SINGH, c. 1854

England
Printed book with leather binding
39 x 30 x 11 cm
Ancient House Museum, Thetford

5.16 TWO PHOTOGRAPHS OF COSTESSEY ATTIC CHAPEL, Early twentieth century

Anonymous
Photographic prints
21.5 x 17 cm; 20.5 x 16.6 cm
Archives of the Roman Catholic Diocese of East Anglia

5.17 TWO PHOTOGRAPHS OF ST AUGUSTINE'S CHAPEL, COSTESSEY

Early twentieth century
Anonymous
Photographic prints; Each 8.5 x 13.5 cm
Archives of the Roman Catholic Diocese of East Anglia

5.18 CHASUBLE, Seventeenth century

Spain
Embroidered textile; 100 x 75 cm approx.
Archives of the Roman Catholic Diocese of East Anglia

5.19 PROFILE BUST OF BISHOP BATHURST
c. 1840
John Herbert (fl. 1820s–40s)
Silver; height 77.7 cm
Norwich Castle Museum & Art Gallery

5.20 QUAKER MEETING HOUSE, GOAT
LANE, NORWICH, 1828
James Sillett
Lithograph; 18.5 x 24.8 cm
Norwich Castle Museum & Art Gallery

5.21 TEXTS FOR EVERY DAY OF THE YEAR,
Early nineteenth century
Given by Elizabeth Fry to woman prisoner,
1836
Ink on paper; 6.8 x 6 cm
Strangers Hall, Norwich

5.22 CHILD'S MUG, WITH HISTORICAL
SCRIPTURE ALPHABET, c. 1820
Possibly Sunderland
Ceramic; 8.7 x 11.9 cm
Norwich Castle Museum & Art Gallery

5.23 CHILD'S MUG, PRESENT FOR BEING
GOOD IN CHURCH, c. 1840
Probably Staffordshire
Ceramic; 6 x 6.3 cm
Norwich Castle Museum & Art Gallery

5.24 NURSERY PLATE WITH MARTYRDOM
SCENE, c. 1840
Probably Staffordshire
Ceramic; diameter 20 cm
Norwich Castle Museum & Art Gallery

5.25 WORKHOUSE CHAPEL CROSS
Late nineteenth or early twentieth century
Mitford & Launditch;
Workhouse Chapel, Gressenhall, Norfolk
Copper alloy; 49 x 22.2 cm
Gressenhall Rural Life Museum, Norfolk

5.26 THE ANNUNCIATION, 1858
Church of St Mary, West Tofts, Norfolk
John Hardman Powell (1832-95)
Stained glass panel; 176 x 55 cm
*By courtesy of the Ely Stained Glass Museum,
on loan from the Diocese of Norwich*

5.27 GREAT WALSINGHAM CHURCH, 1855
Reverend James Bulwer (1794-1879)
Watercolour on paper; 23.2 x 34.6 cm
Norwich Castle Museum & Art Gallery

5.28 PORTRAIT OF REVEREND WHITWELL
ELWIN, Rector of Church of St Michael the
Archangel, Booton, Norfolk, c. 1870
Henry Weigall (1829-1925)
Oil on canvas; 60 x 45 cm
The Churches Conservation Trust

5.29 THE LATE NURSE CAVELL, 1916
Souvenir Postcard
20.7 x 13.7 cm
Strangers' Hall, Norwich

5.30 EDITH CAVELL NORWICH MEMORIAL
SOUVENIR, post 1915
Ceramic; 17.5 x 5.5 x 5 cm
Private Collection

5.31 CHURCH OF ST JULIAN, NORWICH
1828
James Sillett (1764-1840)
Lithograph; 18.8 x 24.8 cm
Norwich Castle Museum & Art Gallery

Notes

i John Wesley, *The Journal of John Wesley*,
Grand Rapids, Michigan, 2000, entry for 23
November, 1757.

ii Matthew Brettingham, *The Plans, Elevations
and Sections, of Holkham in Norfolk...*, London,
1773, p. 7.

iii Norfolk Record Office COL 9/9/29.

iv Norfolk Record Office, COL 9/46/76.

v Andrew Moore with Charlotte Crawley,
*Family & friends, A Regional Survey of British
Portraiture*, 1992, pp. 152-53.

vi L. Sawyer, *Biography of John Randolph of
Roanoke, A selection from his speeches*, New
York, 1844, p. 114.

vii Terry Friedman. 'The Octagon Chapel,
Norwich'. *The Georgian Group Journal*, 13
(2003), pp. 54-77.

viii Art Department, Norwich Castle Museum &
Art Gallery, Bolingbroke MSS, 1827,
pp. 67-78; dated c. 25 May.

ix Richard Ormond and Carol Blackett-Ord,
*Franz Xaver Winterhalter and the Courts
of Europe, 1830-70*, exhibition catalogue
(National Portrait Gallery: London, 1987).

x Betty Elzea, *Frederick Sandys 1829-1904
A Catalogue Raisonné* (Woodbridge, 2001)
pp. 171-72.

xi Roy Hattersley, *Blood and Fire: William and
Catherine Booth and the Salvation Army*, Little
Brown, 1999; *Witness: Women War Artists*,
Exhibition Catalogue, Imperial War Museum
North, 7 February- 19 April 2009.

xii Gavin Stamp, *An Architecture of Promise:
George Gilbert Scott Jr and the Late Gothic
Revival* (Shaun Tyas, 2002).

6

ART AND BELIEF
IN NORFOLK
NOW

Elizabeth A. Mellings

Modern and contemporary art has long suffered the reputation of impenetrability, with artists preferring to chart unfamiliar terrain whilst leaving few clues for viewers to follow. Certainly, with the age of church-led communities in the Western world long past, today's artists may believe what they wish and present their beliefs through a mixture of personal interpretation and commonly understood iconography. Without any obvious moral compass, many are left to navigate their spiritual barks by the stars.

However, such individualism masks the continued influence of organised religion on art. Norfolk's artists, some attached to flourishing faith communities, continue to make sense of life, death and their place in the world by referring to past and present belief-systems. This section of the exhibition draws on the continued association between Norfolk's thriving artistic community and its religious heritage.

Formal religious attendance has declined radically within the last century, suffering a noticeable dip by the 1970s. Despite this, the 2001 census revealed that 74% of Norfolk's population identified themselves as Christian.

This figure contains diverse branches of Christianity, including Catholicism, Protestantism, Anglican High Church, Methodism, Pentecostalism, Quakerism and the Church of Jesus Christ of Latter-day Saints (Mormon). The proportion of Christians and those of 'unstated' religion in Norfolk are above the national average, whilst minority religions are below average, perhaps reflecting the higher percentage of local citizens born within the UK. However, Buddhist, Hindu, Jewish, Muslim and 'other' religions are also evident, ranging from 0.1–0.3%, although Sikhs are now unrepresented and 16.8% of the populace declare themselves non-religious.

Some of these faiths have evolved from Norfolk's earliest known religions. This includes the various Pagan groupings whose numbers, concealed within the catch-all term of 'other', are perhaps attributable to the relative stability of local communities and the rich rural setting. However, much younger faiths, including the Bahá'í community, have also taken root here; whilst the East of England's high international immigration levels suggest that religious diversity will continue to expand.

By presenting some contemporary artworks alongside

earlier examples of Norfolk's unfolding religious narrative, this exhibition demonstrates how artists today, like their forebears, seek to belong by combining tradition and innovation. For all faiths, artists have continued to use and adapt age-old methods and materials to produce religious objects. Religious art has traditionally harboured communal beliefs through a common visual lexicon. Materials may also articulate a faith's creed, evident in Norman Manners's public-scaled but modestly fashioned United Reformed Church Cross (5.11).

Church-commissioned artists and artisans do not necessarily hold the faith but still produce work consistent with received iconographic traditions. For believers, iconography may be translated by the artist's own spiritual engagement and creative negotiation. The often costly and ornate objects used in worship may inspire communal reverence and gain powerful significance through ritual practices. Ceremonial objects designed for the collective holy place are counterpoised by personalised shrines and smaller, humbler items, including prayer mats and rosary beads, made for home-centred daily devotions.

Through art, the ungraspable and invisible can be contained and partially controlled. For some faiths, the making process has consequently become part of religious practice. Communal engagement in making aesthetic objects, witnessed in Hindu rangoli- and sand mandala-making rituals, is deemed as important as collective worship through music and prayer. This, in turn, promotes an exchange of energies and common purposes that unites communities and affirms beliefs. Such activities may extend to global humanitarianism, evident in Quaker and Church of Jesus Christ of Latter-day Saints (Mormon) quilting groups (see, for example, 6.2).

Chris Newby's commissioned film *Something understood* (6.9) seeks to highlight the central place of rituals in the expression of faith, be it in private, home-centred contemplation or through communal worship. Essentially, art-objects are important as facilitators in this process.

For artists attuned to the deeply sacred dimension of interactive ritual, the creative process facilitates a spiritual journey. Buddhist artists, particularly, use the process of making

to encourage religious development. Even for artists who hesitate to declare themselves of any faith, artistic endeavour may produce a form of reverence. Consequently, their work, too, is often spiritually powerful, invoking a sense of the 'sublime' that has remained one of the hallmarks of religious art.

Sacred sites are another place where the material may be made potent through ritual. Many faiths have traditionally focused their prayer away from their immediate locale. For Christians, Muslims and Jews, Jerusalem's Dome of the Rock, made significant by their prophets, remains a central focus for reverence, whilst Islamic prayer is always directed towards the Ka'aba of Mecca.

Nonetheless, Christians and Pagans have, throughout history, also claimed spiritual efficacy for their immediate location. Many Christians and Muslims are inspired by the natural landscape around them, deeming natural wonders to be evidence of the Creator. Moreover, throughout human history, elements necessary for survival have become revered. Raw nature and faith alike continue to inspire fear and awe. The ritual cycle, for many religions, is a means of harnessing natural forces combined with appeals for divine mediation. For this reason, perhaps, the domination of the physical landscape and the central placing of the sun have prevailed in religious iconography, whether represented in the Christian Light of the World, the Light of Islam or in the Pagan reverence for the luminary planets.

As with common religious symbolism, shared religious interest in nature can disguise variations. Landscape often has metaphorical significance. Hindus associate forests with renunciation. For Buddhists, inner and outer realms merge into a constant meditative stream, their landscape imagery encapsulating momentary experience. For Pagans, the potent relationship between landscape, object and ritual is deemed reciprocal, from the sourcing and crafting of materials to the ritual use of the finished object. Through the engaging simplicity of their work, artists Margie Britz and Liz McGowan suggest a dialogue or play between these various meanings (see 2.11 and 2.12).

The spiritual sensations arising from the landscape are

enhanced in Norfolk by the presence of many churches, barrows and henges. Liz McGowan (2.12) and Judith Campbell (6.4) use the intrinsic qualities of local materials to carry Norfolk's cultural legacy into the present. For immigrant artist Margie Britz (2.11), such engagement helps her to comprehend her cultural displacement. Imogen Ashwin draws inspiration from medieval churches and texts in her quest to attain spiritual communion with her environment (6.11). Such site-specific work is influenced, too, by the use of Norfolk's many churches for exhibitions and residencies.

Norfolk's rich visual religious heritage has even engaged atheists. Through his work, John Goto seeks to unravel the conflictual elements of Norfolk's religious past. He exposes defaced rood-screens as sites of artistic transformation generated by a perpetual struggle for theological and political domination (3.9).

Today, local sourcing of materials is also informed by global environmental concerns. These include a continued artistic interest in bodily vulnerability, natural decay and personal and communal identity; all elements suggestive of a burgeoning Humanism. Brüer Tidman reflects upon Christ's exposed humanity (6.6). His raw, direct and personal approach encourages a potential emotional connection with ideas of mortality and eternity.

Finally, art can convey emotion, such as peace or suffering, in a way that text cannot. Consequently, however much cultures and beliefs have changed over the millennia, art is still an indispensable medium for contemplating and expressing beliefs that, though strongly felt, must remain beyond words. Art also reminds us that – whilst the sacrificing of the self to the greater good, rather than dogma, forms the heart of all major religions – every individual's spiritual journey is unique. This experience extends to viewers, allowing art to speak to each of us in the language of our own faith.

6.1 THE UNITARIAN FLAMING CHALICE IN TOUCH WITH ALL FAITHS
1999
Stephen Pask (East Anglia)
Leaded stained glass roundel; diameter 61 cm
The Octagon Unitarian Chapel, Norwich

This stained glass roundel, made for Norwich's Octagon Chapel, perfectly represents the all-encompassing religious embrace of the Unitarian Church. Six intertwined circles, bound by an endless knot of wisdom and compassion, surround and seem to protect the Unitarian symbol of the flaming chalice. However, the light shining out from the core is more than a Unitarian symbol. Light is a central element in nearly all religions, a physical and metaphorical sign of hope and truth. Clockwise from the top, the symbols represent some of the major world religions: Christianity's cross; the Islamic star and crescent; the Hindu symbol for the sacred sound of Aum; Judaism's six-point Star of David; the Taoist Yin Yang (Taijitu) symbol; and the Buddhist Wheel (Dharmachakra).

6.2 BEARS' PAWS QUILT
2007
Ann Lewis (Norwich
Quaker Patchwork
and Quilters)
Cloth quilt
87 x 87 cm
Lent by the maker

This small but striking quilt is one of fifteen replicas of the 'secret message quilts'. It is likely that these were used as coded messages by slaves in 1860s America to guide them to the Underground Railroad. The quilts also serve as reminders of how the Quakers offered safe houses to the slaves. These replicas were made to commemorate the 200th anniversary of the abolition of the slave trade in England. As such, the *Bears' Paws Quilt* illustrates the Quakers' strong and continuing involvement with social reform on a local and global scale, epitomising their compassionate embrace of humanity in its entirety.

6.3 BLOODLINE OF THE BUDDHAS
2007; Chris Loukes (b. 1941, Darjeeling)
Digital video with audio – manipulated sound of chanting monks at Throssel Hole Buddhist Abbey, Carshield, with sea-sounds; loop 36 mins; *lent by the artist*

At one level, *Bloodline* presents a pure abstraction that defines the 'direct line' connecting all Buddhists within Buddha's cycle of reincarnation. The piece refers to a timeless ancestry of faith, allowing Loukes to contemplate his own spiritual placing as a Sōtō Zen Buddhist. However, for Buddhists, inner and outer worlds, surface and experiential depths, individuals and generations form a continuous flow. Loukes selected the video's linear patterns to be in tune with momentary events captured from everyday experience, internalising them as part of his personal meditative quest. The sounds that orchestrate the video's calming balance of line and colour are also firmly embedded within the locality, though 'slowed down, stretched and layered' into near abstraction (artist's statement). The three-tiered, bloodline-naming chants from Throssell Hole Buddhist Monastery are morphed in harmony with the mesmeric rhythms of the sea's gentle ebb and flow against the North Norfolk coastline. This ambient, repetitive sound presents a reassuringly timeless quality, whilst the multilateral flow of lines strike a perceptually comfortable rhythm of continuity and variability, impermanence and eternity. Through this carefully chosen visual alignment, Loukes also consciously references Mark Rothko's affecting and meditative *Seagram Mural* (Tate Gallery, London).

6.4 REQUIEM
2007
Judith Campbell (b. 1942, East Anglia)
Wall-mounted painted panel, gorse; 51.5 x 45.75 cm
Lent by the artist

This sculpture is one of three works made from gorse, gleaned from Salthouse heath after a serious fire. Each stem was carefully chosen to relate to the piece as a whole. In particular, although the gorse has been blackened by the fire, several stems have tiny, red, blood-like 'veins' running through them, offering the suggestion of rebirth. The hexagonal form in this piece has resulted in the central Star of David. The other two works form a diptych, permanently housed in the Chancel of St Nicholas Church, Salthouse. Each work is striking in its simplicity and strongly redolent of place, containing several layers of meaning. The Salthouse diptych was interpreted by the parishioners as representative of the Crown of Thorns, leading to its purchase by the church, the artist's initial concept adapted by the local faith community.

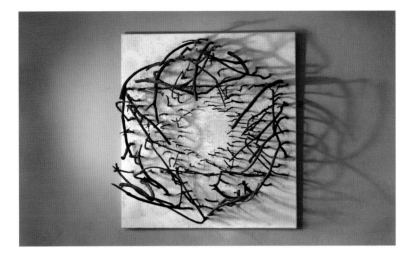

6.5 MYRIADS
2007
Andrew Wilkinson
(b. 1966, Derby)
Acrylic on card,
canvas-mounted
76.3 x 209 cm
Lent by the artist

Myriads was inspired by the prophet and founder of the Bahá'í faith, Bahá'u'lláh, who states in *The Hidden Words* that: 'Myriads of mystic tongues find utterance in one speech, and myriads of hidden mysteries are revealed in a single melody' (Bahá'u'lláh, verse 16). Each of the ninety-five vivid paintings was individually created and ordered through a meditative process, the whole expressing the daily recitation of the word 'Allah'u'Abha' ninety-five times. This Arabic utterance, meaning 'God is the Most Glorious', constitutes a daily affirmation of the Bahá'í Faith. Each unique painting depicts the individual significance and perspective released by this repetitive intonation. The unity within diversity instilled within the painting further affirms Bahá'u'lláh's principle that 'The earth is but one country, and mankind its citizens'.'

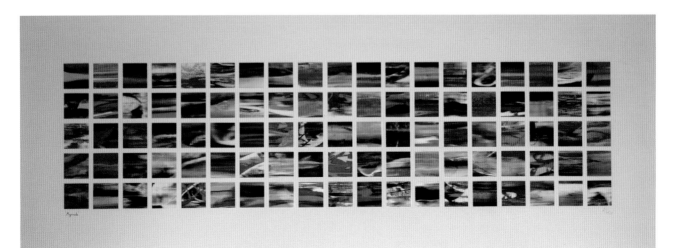

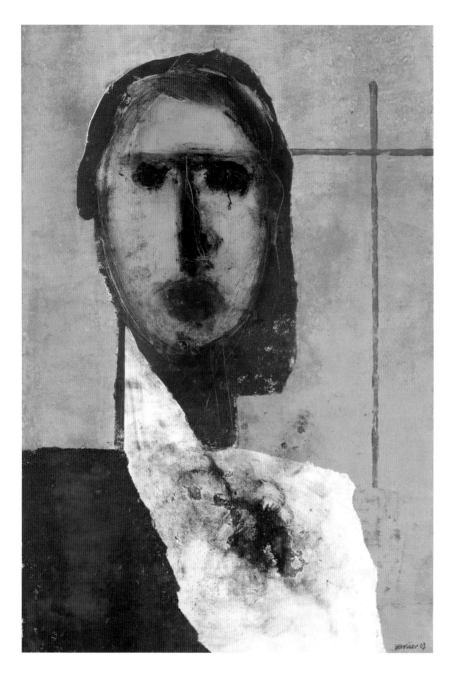

6.6 ECCE HOMO

2003; Brüer Tidman
(b. 1939, Gorleston-on-Sea)
Oil and acrylic on paper
118 x 83 cm
Private collection

Tidman's religious stance is enigmatic. However, in *Ecce Homo* ('behold the man'), an allusion to Pontius Pilate's plea to a hostile crowd to spare the beaten Christ from crucifixion (John 19:5), Tidman's treatment of colour and compositional arrangement is telling. By placing regal blue against a timelessly golden background, Tidman alludes to early iconic depictions of Christ and the Virgin Mary. Simultaneously, his bold and intuitive treatment of colour offers a characteristically emotive response to this subject. The violence of Christ's suffering is evinced by intense scarlet splashes, whilst the sharply linear composition associates Jesus with the portentous cross at his left shoulder, its stark echo defining his face. Conversely, the image is rendered calm through the simple composition and the surrounding golden glow. Its minimal, ordered geometry provides a harmonious balance that overrides all indications of violence with an air of peaceful acceptance. Significantly, this treatment also invokes the philosopher and aesthetic theorist, Nietzsche, whose *Ecce Homo* (1908) proclaimed the value of every individual and the acceptance of one's suffering as a vital part of each unique destiny: *Amor fati.*[ii]

6.7 THE PLACE OF PEACE
2008; Nawala Hoggett
(b. 1964, Baghdad, Iraq)
Textile; 87 x 67 cm
Lent by the artist

Through sacred words, the Iraqi-born
artist Nawala Hoggett seeks to unite the
beliefs and values learnt in her twenty
years in Suffolk with those of her cultural
roots. In this metaphorical piece, Qur'anic
script is transcribed onto the dome of
a stylised depiction of a Mosque. Yet
the Arabic script is written as a phonetic
translation from English, while the
decorative arrangement reduces the
legibility of the words. For, although her
beliefs are essentially Islamic, she does
not follow strict Muslim practices, and her
work reflects private rather than public
worship. Hoggett's empathetic desire is
simply to harness the power of the word
to bring peace, harmony and joy to
people's ordinary lives. In keeping with
this, the work generates its message as
much through its aesthetic attributes as
through the meaning of the words. Her
experiments with new techniques and
materials also show Arabic influences.
Here, she has used a soldering-iron to
burn forms into the metallic fabric. The
colours produced through this burning
process are, like the work's reception,
beyond her control.

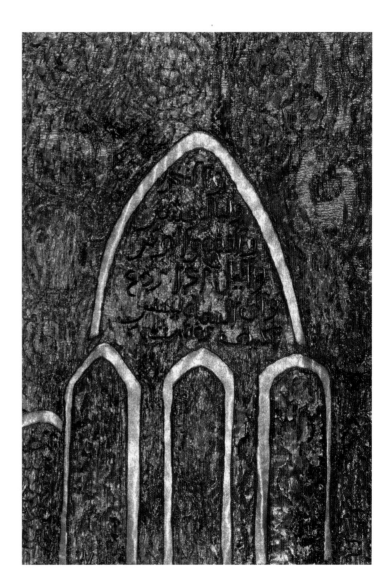

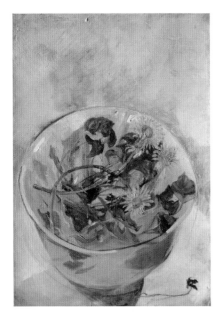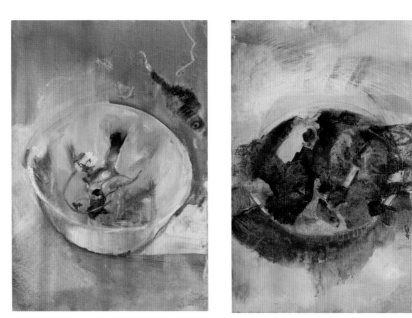

6.8 THREE BOWLS:
RYOKAN'S BOWL; DYING
FLOWERS; BOWL INTO
WELLS-NEXT-THE-SEA
2008
Nicky Loutit
(b. 1943, London)
Three oil paintings on paper,
each 25.4 x 17.7 cm
Lent by the artist

In my little begging bowl
Violets and dandelions,
Mixed together
As an offering to the
Buddhas of the Three Worlds.
 Ryokan

This painterly trio are spiritual manifestations of local artist, Nicky Loutit's Zen Buddhist faith. The paintings depict her pottery bowl, a symbolic container of all she holds dear. Whilst each is distinct, together they follow a theological sequence that relates to the haiku of the Soto Zen Buddhist monk and poet, Ryokan Taigu (1758–1831). The poem describes Ryokan's lost bowl, the floral contents of which are offered to the 'Buddhas of the Three Worlds'.[iii] Loutit's first bowl, as in the poem, contains fresh dandelions and violets in full bloom. The second contains dandelion clocks, representing life's passing into a new yet equally valuable existence; the third is of a stretch of Wells beach, her favourite painting place, in which she is depicted walking her dog. The landscape surrounding this bowl has all but dematerialised. It represents a transformational and contemplative light, through which Loutit's shadowy presence passes in 'mindful walking'. Full or empty, the bowls are potent with the expression and promise of constant spiritual renewal. Momentary experiences blend together, the past is reborn and redefined within the present. For Loutit, the act of painting expresses a meditative 'communion with nature', heightening her spiritual awareness and serving her passage to a higher state. It is her 'life', she says, facilitating her search for the attainment of truth.

6.9 SOMETHING UNDERSTOOD
2010
Chris Newby (b. 1957, Leeds)
Video film, showreel, 15 mins
Norwich Castle Museum & Art Gallery

Chris Newby studied at Leeds Polytechnic and the Royal College of Art. He has made numerous short films for the Arts Council and in 1991 was chosen by the British Film Institute to take part in their New Directors Scheme. The resulting short film *Relax* garnered many awards and he subsequently made the feature film *Anchoress* for the BFI. It was premiered in the 'Une Certain Regarde' section of the Cannes Film Festival. His recent work includes the short film *Metamorphosis*, funded by the Arts Council and Film London, and in 2009 he was one of the first recipients of a FLAMIN productions development award.

Chris Newby's commissioned film represents a personal response to the diversity of devotional practice in Norfolk today. A poetic *étude*, the title references the closing line of the poem 'Prayer (1)' by George Herbert: 'The Land of spices; something understood'.[iv] While the film is centred upon the act of prayer, the artist engages with both the interior places and the exterior spaces which continue to influence artists today, just as the Norfolk landscape itself may be said to have acted as an agent in the expression of faith over the centuries. *AM*

6.10 THE QUANTITY OF A HAZELNUT, 2010
Gary Breeze (b. 1966, Essex)
Incised welsh slate; 50 x 50 cm
Lent by the artist

6.11 GUARDIAN, 2007
Imogen Ashwin (b. 1960, Norwich)
Digital photograph; 80 x 60 cm
Lent by the artist

6.12 THE NAMES OF ALLAH, c. 2003
Makkah, Artist Unknown
Makkan style embroidered textile; 67 x 51.5 cm
Private collection

6.13 HINDU SHRINE, 2010
Norwich and Norfolk Indian Society
Devotional objects; assemblage
Lent by the makers

6.14 QUILT, 2008
Thetford Quilters, Women's Relief Society, The Church of Jesus Christ of Latter-day Saints (Mormon)
Textile; 190.5 x 254 cm
Private Collection

6.15 RITUAL OBJECTS AND MUSIC
Lent by members of Norfolk Faith communities

Notes
i Bahá'u'lláh, *The Hidden Words of Bahá'u'llá*, (Bahá'í Publishing Trust, USA, 1985 reprint).
ii Friedrich Nietzsche, *The Gay Science*, trans. Walter Kaufmann (New York: Vintage Books, 1974), p. 223.
iii T. Ryokan, in J. Stevens (trans.), 'Waka and Haiku', *One Robe, One Bowl: Zen Poems of Ryokan* (Weatherhill inc., new edition, 1987), p. 62, ln. 3.
iv F.E. Hutchinson, ed., *The Works of George Herbert* (Oxford, 1970), p. 51.

PHOTOGRAPHIC CREDITS AND COPYRIGHT

FURTHER READING

Davies, J. and Williamson, T. (eds.), *Land of the Iceni. The Iron Age in Northern East Anglia* Studies in East Anglian History (Norwich: Centre for East Anglian Studies, 1999)

Duffy, E., *The Stripping of the Altars: Traditional Religion in England, c. 1400–c. 1580* (New Haven and London, 1992)

Holmes, P.J., *Resistance and Compromise: the Political Thought of the Elizabethan Catholics* (Cambridge University Press, 1982)

Johns, C. and Potter, T., *The Thetford Treasure: Roman Jewellery and Silver* (London: British Museum, 1983)

Land, J. and Kumar, S. (eds.), *Images of Earth and Spirit. Resurgence Art Anthology* (Green Books: Devon, 2003)

Lipman, V.D., *The Jews of Medieval Norwich* (The Jewish Historical Society of England, 1967)

McClendon, M.C., *The Quiet Reformation: Magistrates and the Emergence of Protestantism in Tudor Norwich* (Stanford University Press, 1999)

Mitchell, W.J.T. (ed.), *Landscape and Power* (University of Chicago and London, 1994/2002, 2nd edition)

Moens, W.J.C., *The Walloons and their Church at Norwich: their History and Registers, 1565–1832* (Lymington, 1887)

Pestell, T., *Landscapes of Monastic Foundation: the Establishment of Religious Houses in East Anglia c. 650–1200* (Woodbridge: Boydell Press, 2004)

Pound, J., *Tudor and Stuart Norwich* (Phillimore: Chichester, 1988)

Pryor, F., *Seahenge: A Quest for Life and Death in Bronze Age Britain* (London: Harper Perennial, 2002 new edition)

Pryor, F., *Britain BC: Life in Britain and Ireland Before the Romans* (London: Harper Perennial, 2003)

Rawcliffe, C. and Wilson, R., (eds.), *Medieval Norwich* (Hambledon and London, London and New York, 2004)

Rawcliffe, C. and Wilson, R., (eds.), with Christine Clark, *Norwich since 1550* (Hambledon and London, London and New York, 2004)

Reynolds, M., *Godly Reformers and their Opponents in Early Modern England: Religion in Norwich, c. 1560–1643* (Boydell Press: Woodbridge, 2005)

Weinberg, R., *Spinning Clay into Stars: Bernard Leach and the Bahá'í Faith* (George Ronald: London, 1999)

INDEX